"Santa María, mother of dos
ruega por nos/otros los cruzadores
Tía Juana patrona de cruces y entrepiernas
ruega por ambas orillas y orificios
San Dollariego, patrón de migras y verdugos
ruega por ti mismo culero"

Guillermo Gómez Peña, "La Prayer del Freeway 5. Untranslatable, ni
pedo," *The New World Border. Prophecies, Poems & Loqueras for the
End of the Century*, San Francisco: City Lights, 1996, p. 198.

" " SANDY EGO Y A

Carlos Fuentes, *Cristóbal Nonato*, México: Fondo de Cultura Económica, 1987.

" " WHEN THE U.S. SNEEZES, TIJUANA SUFFERS PNEUMONIA " "

www.tijuana.indymedia.org

"From the other side of the dry adjacent arroyo shared by the two countries, the
dusty road goes out that, after a short run, leads to the small, poor wooden
hamlet designated on maps by the name Tijuana... "

José Vasconcelos, "Visiones californianas," 1919, in *Divagaciones literarias*, Xochimilco, 2002, p. 95.

"The name? That will be known afterwards.
You didn't have papers.
A fucking Mexican, without papers.
Who makes it without papers?"

Evodio Escalante, "Tijuana Moods," in *Lecturas de Baja California*,
ed. Gabriel Trujillo, Mexicali: Instituto Nacional para la Educación
de los Adultos, 1990, p. 291.

Dear Zooz,

I'm sick of your NYC punk. Here's where the real violence
is. Down in San Diego, the Chicanos are sniping at cars on
the freeways. The Chicanos live in these tracks or gullies
on the hills above the freeways. They don't REALLY live in
gullies; rather they sneak over the Tijuana border and
squat at gullies until they can earn the under-minimum-
wage pittances the rich whites hand out for services such
as MAID and gardener. But this is a lot of money in
Mexico where their extended families are living.

Kathy Acker, "The Meaning of the Eighties," *Bodies of Work. Essays*, London:
Serpent's Tail, 1997, pp. 138–139.

" " TÍA DIEGO AND SAN JUANA. " "

Bill Marsh, in conversation, 2004.

"Are you selling yourself off, city?"

Francisco Morales, "La ciudad que recorro," en *Baja
California Piedra Serpiente. Prosa y poesía (siglos XVII-
XX)*, Mexico: Consejo Nacional para la Cultura y las Artes,
1993, p. 35.

"... and a fault line that apparently hasn't been thoroughly studied...
and which penetrates Tijuana is called 'The Nation' fault line..."

Teodoro Osorio Aviles, *La verdad sobre la falla de San Andrés*, Tijuana: Logos, 1989, p. 23.

HERE
IS TIJUANA!

Black Dog Publishing

Tijuana, instead of a city, more often than not, is a transa. The term comes from Mexican slang and within the border; the transa is experiencing a boom. Transa stands for agreement, bribery, business, intention, reflection, and project. Transa refers to the illegitimate and what happens on the verge; not only of illegality but also of any non-conventional initiative. It is derived from "transaction". A transaction within another transaction – this is how Tijuana functions, Tijuana muddles up everything – Tijuana transa.

Tijuana subverts the identity of the Mexican city. Since its origin in the nineteenth century, Tijuana was a transnational transaction; a mishmash of Mexican identity, a negotiation of interests and identities. As the Mexican-American war ended the Mexican territory decreased in size by 50 percent and the actual territory of Tijuana, as we know it, was determined abruptly as the new limit between both countries. Tijuana appears as a consequence of a conflict and simultaneously as a bridge toward a new Mexican-American relationship. From its Mexican south to its Americanized north, Tijuana was systemized by distrusts. Since its dawn period, the city was aware that its external image differed from the images elaborated within, consequently becoming a passageway for the dark legend of casinos and prostitution as well as its ongoing struggle for 'A Worthy Image of the City'.

Tijuana, in the twentieth century, mutated numerous times from a city of recreation, sex and alcohol, to a city of migration, drug trafficking and globalization. If there is something that defines Tijuana, it is a process of indefatigable semantic restructuring. Within and out of the city, Tijuana is signified as hybrid, illegal, happy, Americanized, postmodern, pure myth, new cultural Mecca – and all of this is simultaneously real and imaginary. In its sequence of radical alterations and its diasporic ingredients, Tijuana could be precisely categorized by this: rapidly de-codifying itself.

Tijuana, by de-codifying and re-codifying itself as sign and city, city-sign, functions in the daily adjustment of its space and multifarious or chaotic self comprehension. Who ever wants to understand Tijuana must realize that its history, its meanings, and its forms are part of popular culture discussion of the city. Tijuana is a passion shared by its citizens, Tijuana is discussed while watching television and eating tacos; waiting in line to cross to the other side. Tijuana as an arduous intellectual problem is a passion, a riddle that fortunately or unfortunately we live in. Waiters, architects, managers, academics, laborers, writers, drug dealers, journalists, street vendors, mayors, and opportunists, all wish to define Tijuana and talk about her.

In the twenty-first century the inquiries into Tijuana promise new transactions. The processes that alter Tijuana and that at the same time Tijuana alters, have bifurcated. Tijuana awaits new concepts, experiences, and forms, because if there is something the city cries out for, is that it does not cease to transform itself. Tijuana is barely getting started.

Since its big bang, there exists a Tijuanalogy. One afternoon three friends were discussing, nothing else, but Tijuana. The three of them conducted one of those discussions that ultimately tend to abolish friendships. At the end of the discussion, there where two very clear issues: one, that the three of them would never be in agreement about Tijuana; and the other, that it was necessary to produce a book that would reunite the different postures about the city in order to extended the conflict to others as well. If there is utility in the US-Mexico border, it is to evidence its ambivalences, contradictions, resistances, and counter-forces. Therefore, Tijuanalogy continues.

In the course of assembling the work, the three friends were also aware that theories, metaphors and habitual images of Tijuana have not realized urban revision there. There exists a type of fault between representations, interpretation, images and realities of the Mexican border. This fault is not necessarily a defect. It could be Tijuana's essence: to manifest its elusiveness, the fact that Tijuana makes paradigms fail. Or it could be that within all this 'disorder' exists a plot waiting to be discovered.

We were an Italian anthropologist, a writer and an architect from Tijuana and since our first encounter it was decided that the book would have to be a transaction of disciplines and disagreements, a transaction between the many discourses about Tijuana (statistical, literary, academic, popular etc.), and its rich visual culture. If many issues separates us, two unite us; one, the three of us live in Tijuana and two, we are convinced that only through a transaction between information, interpretation and images can we get close to Tijuana, or at least, to one of the many existing Tijuanas.

This book is such a compendium; to us this book is a preamble. A preamble, so that the reader continues the investigation into the form and meaning about Tijuana, what Tijuana means. Take this book as an anthology, a Mexican lottery or a de-fragmentation. But we would like to make the reader know that the structure of this book is analogous to the city.

Our work has consisted of hunting down and recycling data, quotes, photographs and sources that narrate the history and structure of Tijuana. A tour of the city that is simultaneously ironic, academic, and photographic. A book of visual tourism, but also a book which reunites three distinct research projects conducted for many years, remixed and combined on a project that has taken two years and resulted, though this vortex of words and images, into a work regarding one the most significant cities of the "New World Order."

The authors and researchers of information and images are not responsible for the unity of this work, Tijuana is unequal to Tijuana. What is included in this work is not everything that exists within the city. Several pieces of data, images, sites and people could not be located, not even in books, stores, bars, the internet or the United States. Not all of the information is reliable, therefore statistics could vary according to the interests involved. To accord images and data would be horrific (at least in 73 percent of the cases). (Don't forget Tijuana is a Transa).

Tijuana can have over a million inhabitants, or more than three. This work does not represent the totality of Tijuana – the totality of Tijuana is only a fragment of Tijuana.

The three researchers of this work make clear that any similarity with reality is a representation, among many. The work does not pretend to cover the complete history of Tijuana. The work is located in the final period of the twentieth century and in the beginning of the twenty-first, as well as in past decades as they influence the many urban presents. In many of the present urbanities, Tijuana belongs to the twenty-first, in others to the twenty-second. It could be that statistics, sources and photographs contradict themselves.

Tijuana is the same, it lacks synthesis.
Welcome to Tijuana.
One more Tijuana.

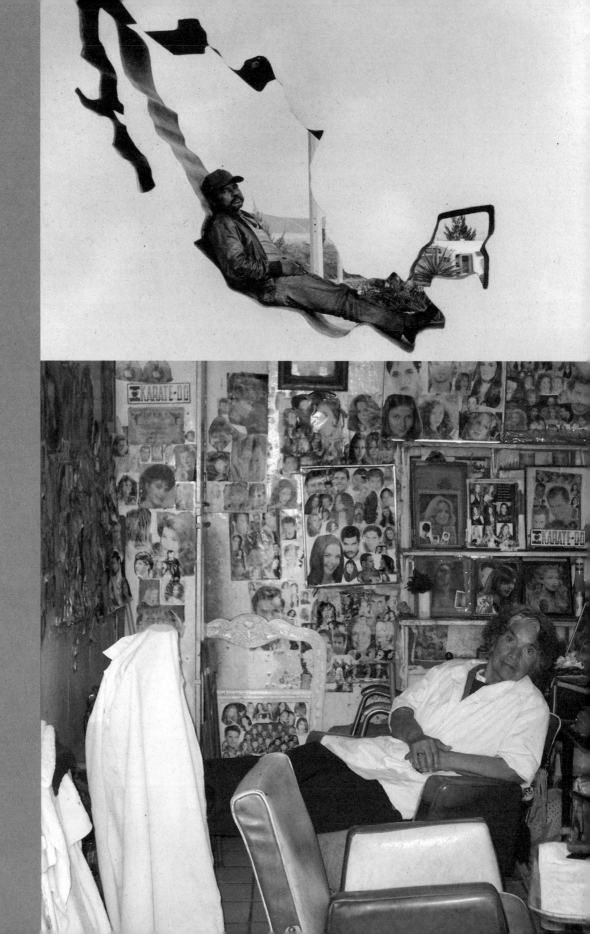

CHAPTER 1
AVATARS

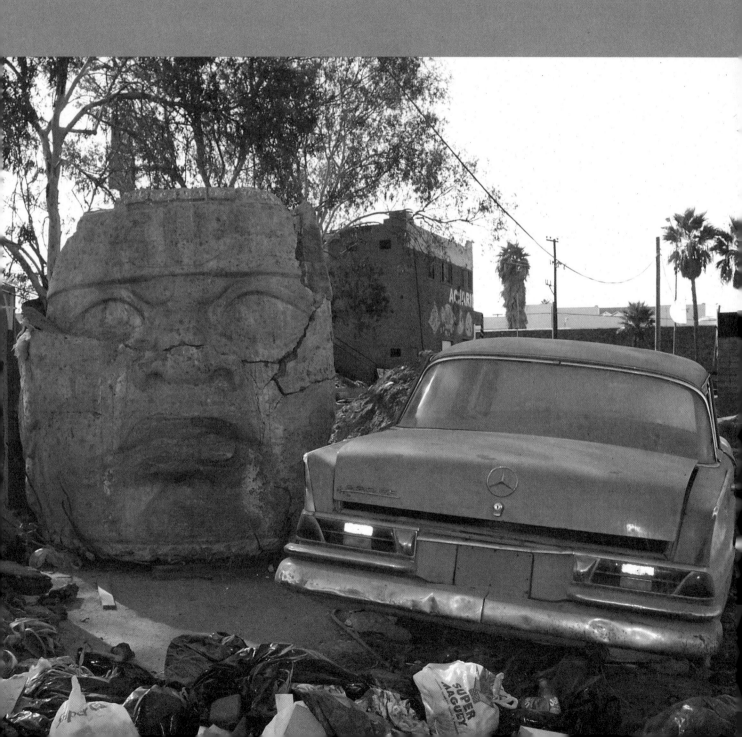

... Introduces us to the strange transformations that occur when Mexico's ancient
cultural heritage reaches that country's northern border, in this case, that
most delirious zone at the border's western extreme, a region where San
Diego's military bases and million dollar ocean view homes rub against
Tijuana's post-apocalyptic landscape wasted by neo-liberalism, a space
where the hybrid and the syncretic are the norm, and where mutations,
no doubt induced by the tons of toxins dumped by the area's many
maquiladoras, proliferate madly.

Jesse Lerner, "Borderline Archeology," translated into Spanish in *Replicante*, no. 1, 2004, p. 33.

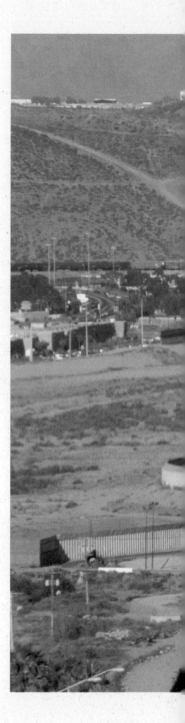

Two paradoxes, then. One is that the place of greatest interaction between
Mexico and the United States is at the same time a place occluded by the
fence. The other consists in that the Tijuana–San Diego passage, the site
where the two countries most approach each other and where more people
of one side come to the other (60 million crossings each year), is not the
zone in which what 'common sense' supposes most representative of each
nation is found. It is possible to think that these misalliances have very
much to do with the fact that one must 'invent' scenes about the other.
Misunderstandings stir up simulacra.

Néstor García Canclini, "El arte público re-imaginado en la frontera," in *Intromisiones compartidas.
Arte y sociedad en la frontera México/Estados Unidos*, eds. Néstor García Canclini and José Manuel
Valenzuela, México: Conaculta–InSite97, 2000, p. 58.

The State of Baja California retained, for Mexico, part of upper California, what
today is the Municipality of Tijuana, and part of Tecate. The United States
did not know where was the exact Southern limit of the land snatched
from our country.... Although it's better not to speculate too much about
the United States' mistake.

Celso Aguirre Bernal, *Breve historia del Estado de Baja California*, Mexicali: Ediciones Quinto Sol,
1987, p. 134.

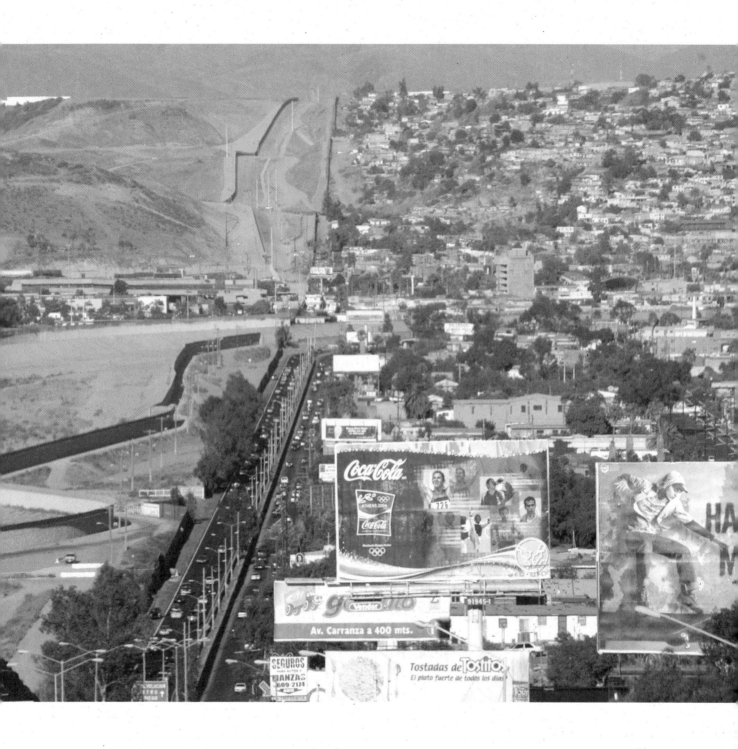

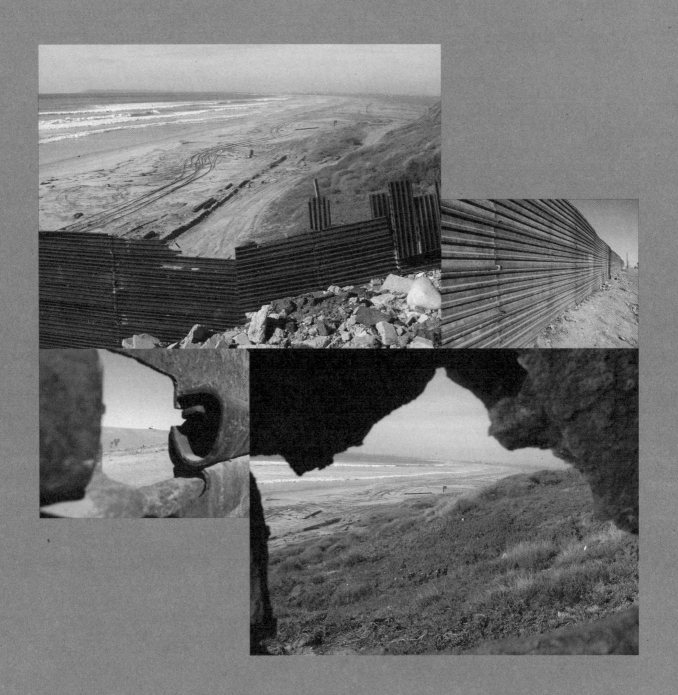

Once upon a time there was a border city with identity problems. It thought itself unique, different; it suffered. There was speculation about its degree of trans-culturation, its geographic condition, and about all those adjectives with which it had defined itself. It turned its face toward Mexico, then towards the sky; next toward the United States. It couldn't find itself. It tried to explain itself to itself. Who knows why, in rainy periods it imposed a state of siege to read and reflect on its condition: 'This city that hurts us like a thorn in the side,' and furiously threw the book toward its stagnant streets. It opened another book and only found nostalgic crumbs, early loves. My beaches considered lukewarm? No way! it said when it read that in the reports of some depressed man and, at the same time, it tried to get rid of the sewer waters and garbage coming from the neighboring cities. Sick of everything, it decided: 'I'll be what I am not,' it said, making a grimace that showed pride. It opened a notebook, took out a pen, and jotted down: 'The city as montage.' 'Don't try to hold your breath or count to ten.' 'Don't waste your time, get up and go; listen to life in general revealing itself.' 'The reader cannot help you; he is away, distant, in another city, his, another very similar city.'

Guillermo Sánchez Arreola, "La frontera como montaje," *Equis*, no. 9, January 1999, p. 12.

- A third of the money that undocumented persons (popularly known as pollos – literally 'chickens') pay to be crossed by smugglers (polleros – 'chicken dealers') ends up in the pockets of Mexican and United States immigration officials.

México: Comisión de Población, Fronteras y Asuntos Migratorios de la Cámara de Diputados, Official Report, 2003.

- In 2000, the earnings of traffickers of illegal persons along the border went up to more than $7,000 million, according to the U.S. Department of State.

- Contrary to popular belief, the majority of these smugglers are U.S. citizens.

- 123 smugglers were detained at the Tijuana-San Diego border crossing during 2003, 89% of whom were North Americans.

- The majority of these organizations are directed by Anglo Saxons.

www.mexidata.info/id145.html

- From 1987 to 2004 the House of the Migrant in Tijuana – with a quota of 200 people at a time – received 130,000 migrants stemming from Mexico and Central America. Around 40% of its guests are migrants deported from the United States.

Casa del Migrante, Tijuana, 2004.

- In 2000 the immigrant population of Baja California was 11.73%, the second highest percentage in the whole country, surpassed only by Quintana Roo. Its emigrant population was 3.26%

XII Censo General de Población y Vivienda, INEGI, 2000.

- In the first years of the twenty-first century, the National Institute of Migration in Baja California reports that of those illegal foreigners detained, first place was held by Guatamalans, the second by Brazilians. This second place is a novelty of recent years.

www.frontera.info

Agua Caliente's union leaders organized a strong movement protesting against the expropriation…. Of course this movement was covertly supported by the economic interests of North American card sharps like Jim Crofton, one of the associates of Agua Caliente. President Cárdenas gave an order of expulsion of this individual from the country, as a dangerous foreigner…. In this framework of agitation a tragedy occurred that came to stir people up and provoked a violent end in the 'strike of the seated ones': Olga Camacho, the young daughter of one of the movement leaders, got lost and was later found strangled and raped. The criminal turned out to be a soldier, Juan Castillo Morales… his own wife, horrified, pointed him out as guilty, showing the soldier's bloody clothes. Afterwards – irony of ironies and perhaps because of the social tension that was linked with these events, as well as because of the coarse application of the 'death by cop' law to delinquents in the view of the citizens – he was exonerated by public opinion. He was made a victim of injustice, and today among the lower classes he is revered as 'Juan Soldado,' images of him are printed, and miracles are attributed to him, above all as patron saint of undocumented persons, those whom he 'helps to cross illegally to the United States.'

David Piñera y Jesús Ortiz, *Historia de Tijuana. Semblanza General*, Tijuana: Centro de Investigaciones Históricas UNAM–UABC, 1985, pp. 136–137.

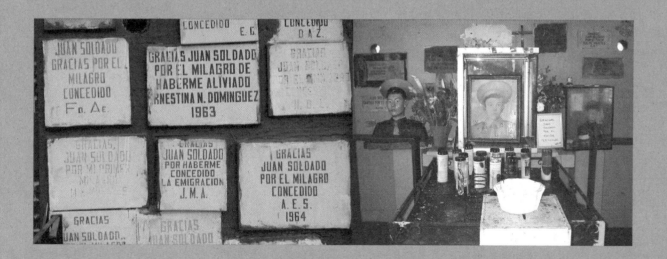

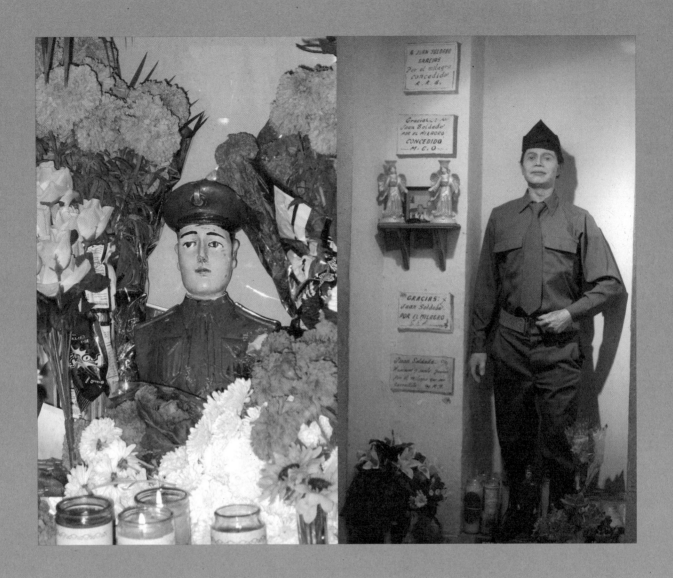

"I AM FROM TIJUANA. ONE DAY LET ME CROSS TO THE UNITED STATES THROUGH THE BIG DOOR... WITHOUT HAVING TO HIDE FROM ANYONE."

Petition of a follower of Juan Soldado.

Among these population movements, the best known and perhaps the most
 important is that of the commuters, who are persons whose residence is
 in one country but who move, sometimes every day, to the neighboring
 country to work. But we also see another order of daily displacements of
 persons across the border that happens because of equally important
 reasons, such as to study, to get medical attention, to make purchases,
 to make use of different services, and for recreation. Similarly, through
 frequent visits to family and friends who live nearby in the other country,
 they seek to satisfy emotional needs.

Norma Ojeda y Silvia López, "Familias transfronterizas en Tijuana: dos estudios complementarios,"
Tijuana: El Colegio de la Frontera Norte, 1994, pp. 11–12.

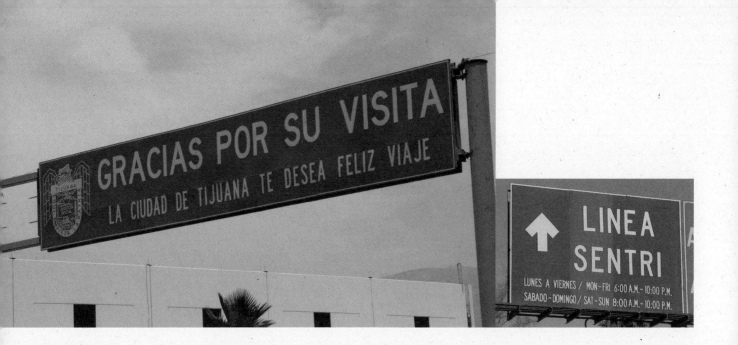

Not long ago, after a lecture in San Diego, I paid a visit to Tijuana. Among those
along for the ride was my friend Omar, a Palestinian architect who had just
begun his Fulbright at Irvine. Omar was depressed. Lost in the invidious
sprawl of right-wing heaven, he was having a bad dose of suburban agoraphobia.
Car-less, he was stuck in his apartment, forced to walk for miles to buy a
quart of milk.

We collected him at the San Diego station and headed south as Omar recited
his tale of woe. Orange County was, for him, both completely alien and
terribly familiar. The tile-roofed gated communities — fortified against some
unspecified Other — were of a piece with the Israeli settlements in their
architecture of exclusion and made him feel the more a second-class citizen.
His despair was palpable as we tried to cheer him up with promises of
camaraderie, seafood, and Tequila.

As we joined the checkpoint queue to cross the border, though, his mood
lightened measurably. The scrutiny of armed guards cut through his home-
sickness and he felt suddenly at home. Laying eyes on the city itself, on the
thick pattern of life, on the graffiti daubed along the fence, he began to smile.
Arriving at a seaside bar, he became positively delighted. 'I love this place,'
he announced. 'It could be Gaza.'

Michael Sorkin, email conversation, New York/Tijuana, 2004.

- According to Market Technical Research and Channel 12 (XEWT), in 1998 Tijuana had 1,834,519 inhabitants. Its average age was 24 years, and Tijuanans spent $8.2 million daily in San Diego, with an average of 3.5 weekly crossings, of which 80% were by car.

Powerful Hispanic Market of San Diego and Tijuana, Tijuana-San Diego, 1998.

A typical dialogue would go like this:
'What are you bringing from Mexico?'
'Nothing.'
'What are you bringing from Mexico?'
'Nothing.'
'You have to answer 'yes' or 'no.' What are you bringing from Mexico?'
'No.'
'Good. Go ahead.'

Luis Humberto Crosthwaite, "Recomendaciones," in *Instrucciones para cruzar la frontera*, México: Joaquín Mortiz, 2002, p. 11.

- 24% of all North-bound border crossings is to work in San Diego.

- 1/10 of Tijuana's entire workforce works in San Diego.

- Tijuana is one of the most affluent markets in Mexico.

- 1 out of every 2 inhabitants are white collar.

San Diego-SANDAG 2020 Ethnic Population estimates/Tijuana-San Diego Dialogue Study.

Strategy Research Corporation 1998 U.S. Hispanic Market Blue Book/Tijuana.

1990 HMRC Tijuana Market Study.

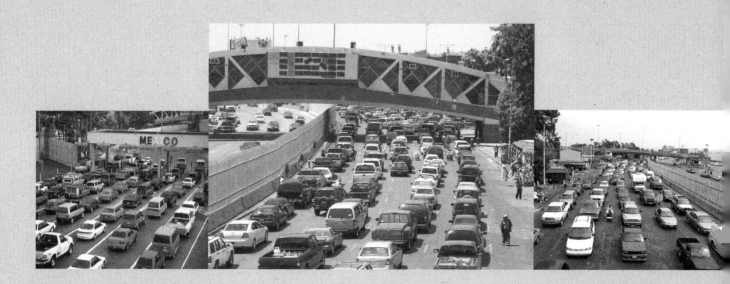

TWIRL: TIJUANA WORLD INVOLVES RESPONSIVE LANDSCAPES

Like a yin-yang symbol, the border has become less straight, less a knife edge and more a twirling, blurring line of transgressions, of reciprocities hidden with U.S. dominance. An evolving cultural mix of blood, money, economies, cuisines, and territories. As improbable as it seems, implanted on this festering, highly fluctuating landscape is an American grid, the grid of the city of Indianapolis! But this grid, in all its attempts to democratize and equalize space, is nothing more than a graph paper background to the TWIRLing phenomena of Tijuana. Like a Zen garden, where one should not look at the rocks, but rather between them, we should not concentrate on the border but the TWIRL. It is a double helix, a new urban DNA strand, not simply of Mexico and the U.S., but of a strange and incredibly vital deep space where micro cultures stand as tall as more dominant ones. For every cheap knock off pharmaceutical available to Socal housewives and college students alike, there is some north-of-the-border hot dog, ersatz taco, or whateverburger offered to the locals. Yet this apparently logical equation belies a greater complexity at work in the regions interlocked in the TWIRL. Although the interminable wait demanded at the Border Station is a constant reminder of issues of status and identity, the whole flow of pathways, real and virtual, renders the Station as nothing more than a halo of security. It is this place that is indeed at the physical heart of the TWIRL, but its porosity and cloudiness are its most real, most effective properties. The border dis-unites, precludes, slices off. TWIRL encompasses and includes and its constant turbulence is what life is actually made of.

Neil Denari, email conversation, Los Angeles/Tijuana, 2004.

Tijuana was officially founded in 1889.

In 1719, Father Clemente Guillén wrote he had arrived to a ranchería called 'San Andrés Tiguana.' In 1809, Father José Sánchez probably turned an indigenous name into Spanish, from a native convert of 54 years, writing in his baptismal book 'from the Ra. la Tia Juana.'

In 1925 the city was named 'Zaragoza' but then was definitively changed to Tijuana in 1929.

To clarify the meaning of the word Tijuana it is argued that its origin goes back to the corruption of the sound, stemming from the Yuman language, '*Llantijuan*,' the meaning of which would be 'close to the sea,' or 'place of scarce foodstuffs.' The Guaycura has an identical sound. The exact indigenous etymology continues to be discussed.

Another hypothesis attributes the name to a small nineteenth century ranch known as 'Tia Juana,' belonging to a woman of that name or to an Indian chief; one of its variants came also to be 'Tio Juan.'

Miguel Mathes holds that the place name has appeared also as 'Tiguana,' 'Tiuana,' 'Teguana,' 'Te-a-wa-na,' 'Tecuan,' 'Tecuam,' 'Teguan,' 'Tiwana,' 'Tijuan,' and 'Ticuan.'

Elsewhere on graves dating back to 1882, the gravestones are inscribed with 'La Tifuana,' which reiterates that already from its beginning the city's name would occur in different versions and in mistaken versions, as well as etymologies that go back not only to indigenous languages or to Castilian Spanish, but also even English is attributed a certain influence in its final composition; certain sources suggest that the expression 'Tia Juana' suffered morphological syncope until it turned into 'Tijuana' owing to the pronunciation of the English of the abbreviation 'T. Juana.'

In its very name the city already represents the tension of multiple origins and shows that there is no definitive synthesis, since on careful observation the city goes back to reestablishing its heterogeneity and conflict.

The name of the city has been transformed into the name of pornographic posters from the beginning of the century – the famous Tijuana Bibles – horses, artists, personalities, spectacles, musical groups – from the Tijuana Brass to Tijuana No – and is part of the title of hundreds of books, websites, movies, songs, neighborhoods in other countries, and all kinds of business enterprises.

In 1997, owing to the media 'abuse' of 'Tijuana,' the city government decided to register the word with the Mexican Institute of Industrial Property (trademark).

Some have claimed this copyright is a bluff.

The measure tried to prevent the use of the word as damaging of the 'public image' of the metropolis. In 2004 the City Council of Tijuana, in its project to 'purify' and 'dignify' Tijuana, declared the city as 'Heroic' for its defense in 1911 against the anarchist forces of the Flores Magón brothers who had taken control of the city that year.

In spite of the copyright of 'Tijuana' – which has not worked out in practice – and of the fact the 'cleansing of the name' of the city has changed into a central objective of recent administrations, which strive for a 'New Tijuana,' the city goes on generating all kinds of definitions, baptisms, connotations, titles, and imaginal constructs.

Outside and within it, the city is simply referred to as 'TJ' or 'Tijuas.'

From David Piñera Ramírez, *Historia de Tijuana. Semblanza General*, Tijuana: Centro de Investigaciones Históricas UNAM–UABC, 1985.

Tijuana and San Diego are not in the same historical time zone. Tijuana is poised
 at the beginning of an industrial age, a Dickensian city with palm trees. San
 Diego is a postindustrial city of high impact plastic and despair diets. And
 palm trees. San Diego faces west, looks resolutely out to sea. Tijuana stares
 north, as toward the future. San Diego is the future – secular, soulless. San
 Diego is the past, guarding its quality of life. Tijuana is the future.... Taken
 together as one, Tijuana and San Diego form the most fascinating new city
 in the world, a city of world-class irony.

Richard Rodríguez, *Days of Obligation. An Argument with my Mexican Father*, New York: Penguin Books,
1992, pp. 84 and 106.

Along the Mexico-United States border there is now an unprecedented mixing,
 producing many new cultural and aesthetic forms. For instance, there are
 more Chinese restaurants in Tijuana than any other city in México, and the
 desert region outside Mexicali is home to many people of Middle-Eastern
 origin. Nearby, on the U.S. side of the border (and in Tijuana on the
 weekends) there are military and surfing cultures. The booming Mexican
 corrido industry is headquartered in Los Angeles. Tijuanenses and San
 Diegans can watch television channels that are broadcasted from either
 side of the border in many languages. Mexican movies become box-office
 hits in the United States, including for instance *Amores Perros* (2000,
 Alejandro Gonzalez Iñarritú) and *Y Tu Mama También* (2000, Alfonso Cuarón).

Michael Dear and Gustavo Leclerc, *Postborder City. Cultural Spaces of Bajalta California*, New York:
Routledge, 2003, p. 8.

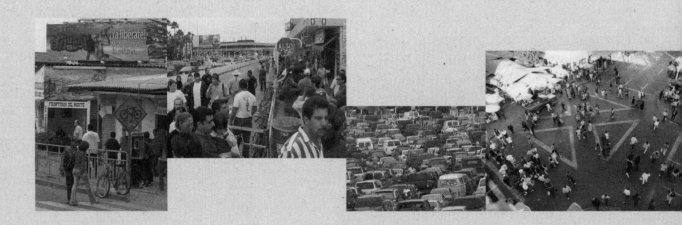

■ To cross the border illegally in the
trunk of a car costs $2,500. The
average number of cars abandoned in
the crossing lanes towards San Ysidro
is 3 to 4 per month. "These people
are mainly abandoned because those
who are trying to cross use stolen
cars... and on days when the lines
are long, the cars break down."

Chief of Police for Tourism, *Frontera*, www.frontera.info

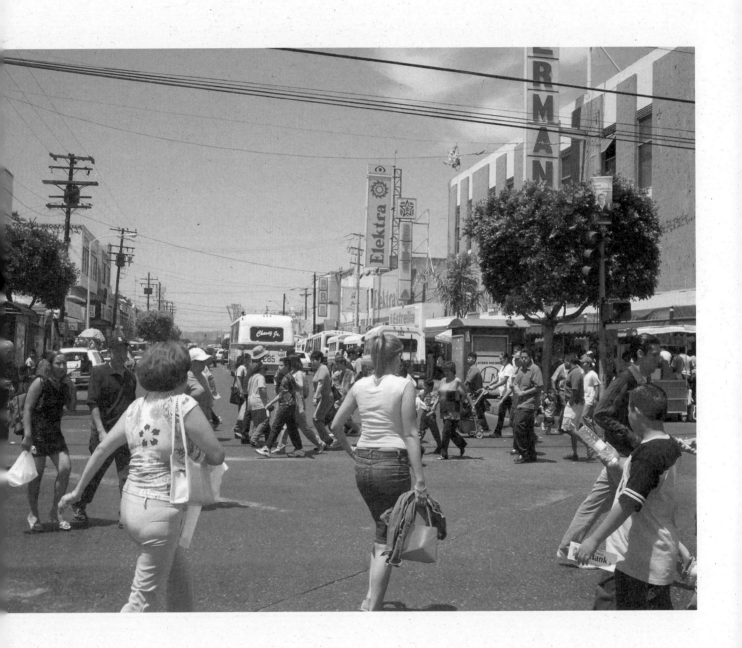

From the beginning of the twentieth century until some 15 years ago Tijuana was known for a casino (abolished in the Cárdenas administration), cabarets, dancing halls, liquor stores, where North Americans arrived to avoid the sexual prohibitions, games of chance and alcoholic drinks of their country; the recent construction of factories, modern hotels, cultural centers, and access to a broad range of international information has turned Tijuana into a modern and contradictory city, cosmopolitan and with a strong definition of its own... during the two periods in which I studied the intercultural conflicts of the Mexican side of the border, in Tijuana, in 1985 and 1988, at various times I thought that this city, next to New York, is one of the great laboratories of postmodernity.

Néstor García Canclini, *Culturas híbridas. Estrategias para entrar y salir de la modernidad*, México: Grijalbo, 1989, pp. 293–294.

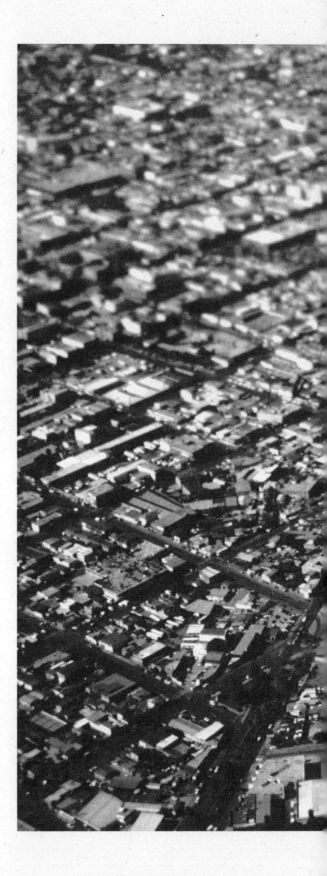

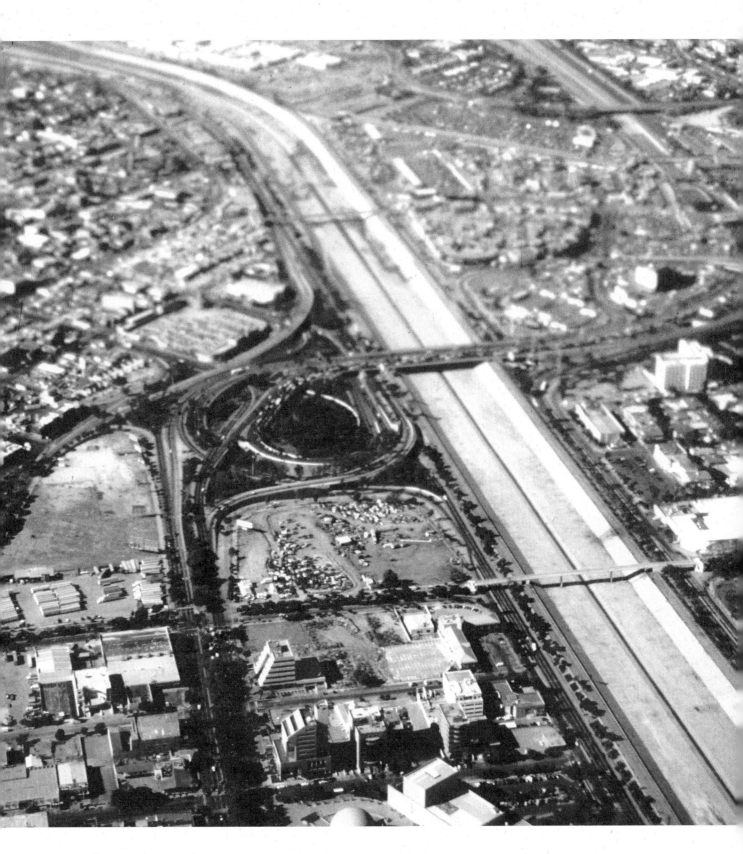

WHAT ARE THE MOST COMMON INFRACTIONS AND MISDEMEANORS COMMITTED BY VISITORS IN TIJUANA?

Disobeying a legitimate order given by a public authority. Lighting or exploding fireworks. Disorderly conduct or disturbing the peace on a public street. Disorderly conduct or disturbing the peace while intoxicated. Loitering on a street, which causes a public nuisance. Using costume or disguises which causes a public nuisance. Creating excessive noise with cars, motorcycles or equipment. Appearing undressed (naked) in public. Crimes relating to drugs, alcohol or prostitution. Satisfying physiological needs (excreting or urinating) on the street. Introducing or drinking intoxicating beverage in public or private places without authorization. Drinking alcoholic beverage in a vehicle while on a public street or road.

Ayuntamiento de Tijuana,
www.tijuana.gob.mx/turismo/TouristGuide/English/index.asp

SOME OF THE BIGGEST PROBLEMS THAT FACE THE BUSINESSMEN OF REVOLUTION AVENUE AND THE TOURIST ON FOOT ARE THE FOLLOWING:

The workers of the bars, restaurants, and curio salesmen who are called 'barkers,' those who grossly and rudely invite tourists to enter the businesses that they represent, usually remaining throughout their shift on the sidewalk. The large number of traps that the businessmen set for the pedestrians entering our city or along the ways where tourists walk, like store windows, metallic structures to hang merchandise, ads (that extend altogether to stretches of the sidewalk), furniture, and the strolling vendors who establish their fixed spot using the sidewalks.

An increasing number of people (older people and minors) dedicated to soliciting donations of money from tourists and local passersby.

DEMANDS OF BUSINESSMEN IN THE TOURIST AREAS:

The lack of bilingual tourist police. With this knowledge they could orient and help foreign tourists.

A limited police presence, so that they demand that it be increased.

Application of the most energetic and effective means on the part of the Direction of City Regulation, toward transient businesses, as well as the control of certain strolling vendors who work under the influence of toxic substances or are inebriated.

The presence of probable delinquents who stroll through the tourist area awaiting prey so that they can take their belongings.

Ayuntamiento de Tijuana, Secretaría de Seguridad Pública Municipal, 2002.

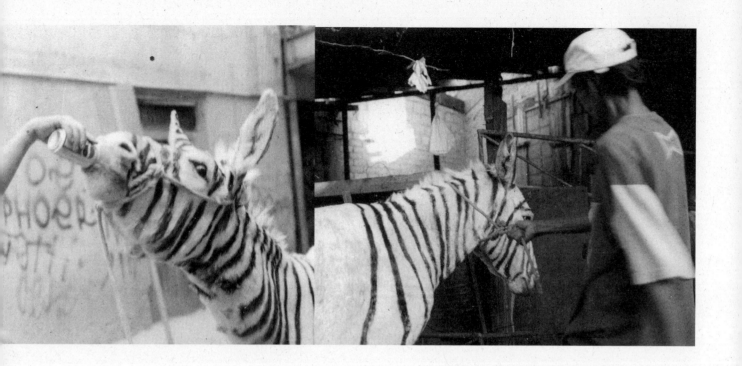

The genius of a gentleman by the name of Gabaldino Gaytán created one of the great traditional tourist attractions. Since the 1920s carts have been seen, with their donkeys painted with stripes and with broad hats so that tourists would touch them, along the side of the road, to have their pictures taken.... At some point they became the symbol of Tijuana, when some round decals were widely distributed with a little painted donkey carrying a branch of paper flowers.

Juana Irene Contreras de García, *Al rescate de los sitios históricos de la Vieja Tijuana*, Tijuana: Fortisa, 1991, p. 30.

WHILE TIJUANA IS NOT SUBJECT TO A CURFEW AND HAS NOT BEEN PLACED OFF-LIMITS, COMMANDS ARE URGED TO COUNSEL SERVICE MEMBERS TO EXERCISE CAUTION IN TIJUANA, ESPECIALLY AT NIGHT. THE MAJORITY OF THOSE VICTIMIZED IN TIJUANA ARE INDIVIDUALS WHO BECOME INTOXICATED AND SEPARATED FROM FRIENDS, RECONFIRMING THE IMPORTANCE OF THE BUDDY SYSTEM AND SOBRIETY.

Home Land Security, USCG, 2001.

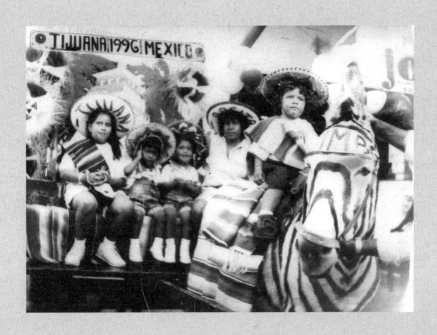

MY LEFT BANK I grew up along the border in the 1950s and early 1960s. The two most important events in my adolescence were joining the civil rights movement (Congress of Racial Equality) in San Diego when I was 16 (1962) and – intimately related – discovering a new world across the border. San Diego in this period was a segregated, reactionary city with a stifling civic culture, dominated by the San Diego Union, and zero tolerance for leftish or unorthodox ideas. Rebellious, incipiently radical kids like me hung out at a few 'beatnik' coffee houses or in the basement of Wahrenbrocks' Bookstore downtown. But we only really felt free when we had crossed the border. Tijuana was our portal to an entire universe of forbidden and wonderful ideas. My first exposure, for example, to the immense heritage of European Marxism and Critical Theory was at the old El Dia bookstore off Revolucion. In Tijuana we met Spanish Republicans, listened to lore from elderly Villistas, and debated politics with sophisticated college students. It was in Tijuana that I first began to appreciate the impact of the Cuban Revolution and was first able to see the U.S. civil rights struggle in larger perspective. Tijuana also kindled the desire to keep going southward, toward that great other America we learned nothing about in schools. Most San Diego high school kids in this era, of course, crossed the border to drink, insult locals, and leave behind a trail of vomit and bad manners. We hated that. Tijuana for us was a little bit of Paris, our personal Left Bank, and my fondness for the city and the cultural freedom it represented has never waned.

Warmly, Mike Davis

Email conversation, San Diego/Tijuana, 2004.

The relation between gringos and Mexicans in Tijuana is a performance in which the Mexican feigns service and inferiority so that, in the end, he can take advantage of the North American tourist.... North American culture at no time truly threatens to 'contaminate' Mexican culture, since contact among people of these two ethnic and cultural groups is minimal, completely insignificant, and is only reduced to business contacts and interactions.

Diana Palaversich, "La Vuelta a Tijuana en seis escritores," *Aztlán: A Journal of Chicano Studies*, vol. 28, no. 1, 2003, p. 116.

- According to Richard F. Gonzalez, United States Consul General in Tijuana, 67% of the inhabitants of southern California have not visited Tijuana, 'mainly because of negative information about the city.'

Newspaper *Frontera*, www.frontera.info

- Downtown Tijuana is visited by 116,000 people daily.

Local television, Channel 12, Tijuana.

"

VISITORS TO BORDER CITIES SUCH AS TIJUANA, CIUDAD JUAREZ, AND NUEVO LAREDO SHOULD REMAIN ALERT AND BE AWARE OF THEIR SURROUNDINGS AT ALL TIMES. "

U.S. State Department, http://travel.state.gov/mexico.html

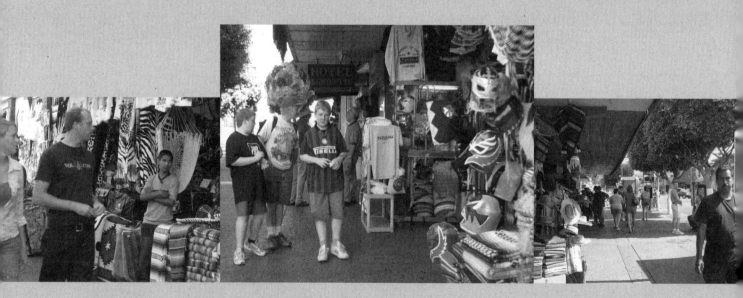

- **75.08%** OF TOURISTS COME FROM SAN DIEGO, LOS ANGELES, AND SAN FRANCISCO.

- **60%** ARE BETWEEN **25** AND **50** YEARS OLD; **28%** BETWEEN **18** AND **25.**

- **42.56%** ARE EMPLOYED; **14.86%** ARE PROFESSIONALS; **12.81%** ARE SELF-EMPLOYED; **8.61%** ARE STUDENTS; **7.55%** ARE RETIRED; **7.23%** ARE BUREAUCRATS; **4.23%** ARE HOUSEWIVES; AND **2.12%** ARE IN THE MILITARY.

- **32.18%** OF FOREIGN VISITORS EARN FROM **$21,000** TO **$35,000** ANNUALLY; **27.02%** FROM **$36,000** TO **$50,000**; **18.39%** FROM **$51,000** TO **$100,000**; **17.24%** FROM **$10,000** TO **$20,000**; AND **5.17%** EARN MORE THAN **$101,000** ANNUALLY.

- THE AVERAGE STAY OF A FOREIGN VISITOR WHO DOES NOT SPEND THE NIGHT IN THE CITY IS **2.4** HOURS, AND HE SPENDS **$48.30.** THE AVERAGE GROUP IS **1.5** PEOPLE.

- VISITORS THAT DRIVE IN AND SPEND THE NIGHT IN THE CITY TRAVEL IN GROUPS AVERAGING **2.4** PEOPLE; THEY SPEND **$126.90** PER PERSON; AND THEIR STAY IS **2.9** DAYS LONG.

- IN **2002** THE AVERAGE COST OF A HOTEL IN TIJUANA WAS **609.57** PESOS.

- AROUND **50,000** LOCAL FAMILIES DEPEND ON TOURISM. THE ANNUAL YIELD FROM THIS SECTOR IS MORE THAN **530** MILLION DOLLARS, GENERATED BY THE **15** MILLION TOURISTS WHO VISIT.

Tourism and Conventions Committee, 2002.

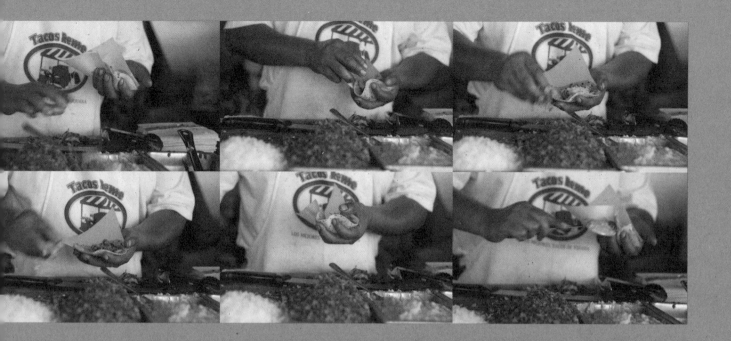

Contrary to certain stereotypes, tacos continue to surpass hamburgers in popularity as a street food. Although a good part of the ingredients of the Mexican taco now come from the United States. A taco of goat meat costs 10 pesos, but prices vary. Three pork tacos can cost a dollar. Miguel, a taco vendor on Coahuila Street, stocks up on 8 kilograms of meat every ten hours, 400 pesos. Mechanics, housewives, employees of factories and businesses come to his spot. Among the most recognized taco spots in town are "El Frances" (tacos), "El Gordo" (mulitas), and "El Dorado" (fish tacos). It's customary to go for tacos after leaving the bars. According to Miguel, the majority of tourists don't eat tacos. "They're afraid they'll get sick."

Interview, 2004.

The invention of the Cesar salad is attributed to Livio Santini Naimor, who according to this version in 1925 designed it for the customers of Restaurante Caesar's located on Second Street in Tijuana.

Aida Silva Hernandez, *Perfiles de Tijuana, Historias de su gente*, Tijuana: Consejo Nacional Para la Cultura y Las Artes, 2003, p. 113.

Typical food has a seafood base, for example, shark-fin soup, shrimp soup, turtle, lobster, and turtle-meat tamales.

Baja California. Tierra extremosa y riqueza de los mares, México: Secretaría de Educación Pública, 1992, p. 200.

CHICKEN [SHE CAN] TRY IT. AND IF YOU WANT, I CAN HARA KIRI [THE] PRICE. "

Vendor on Revolution Avenue addressing two Asian American clients.

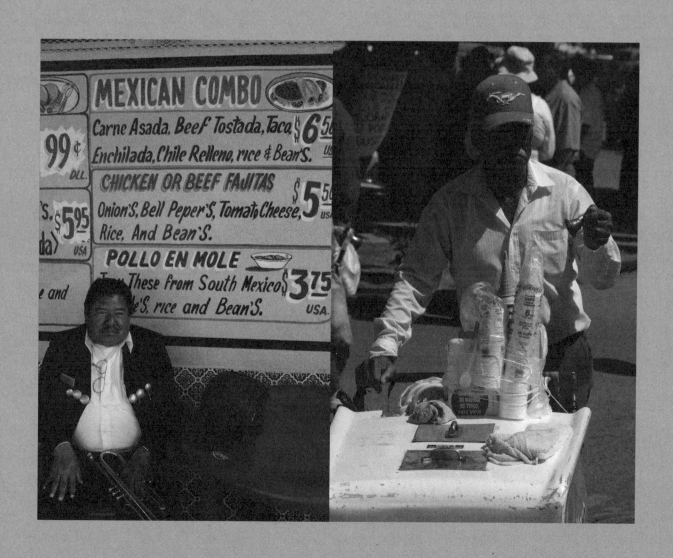

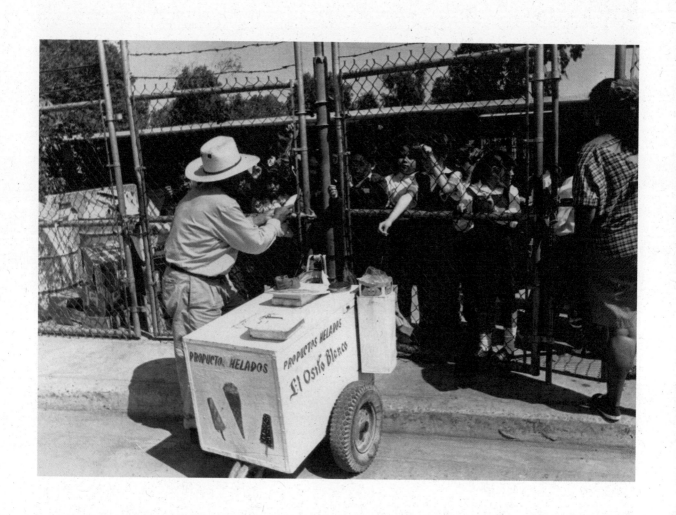

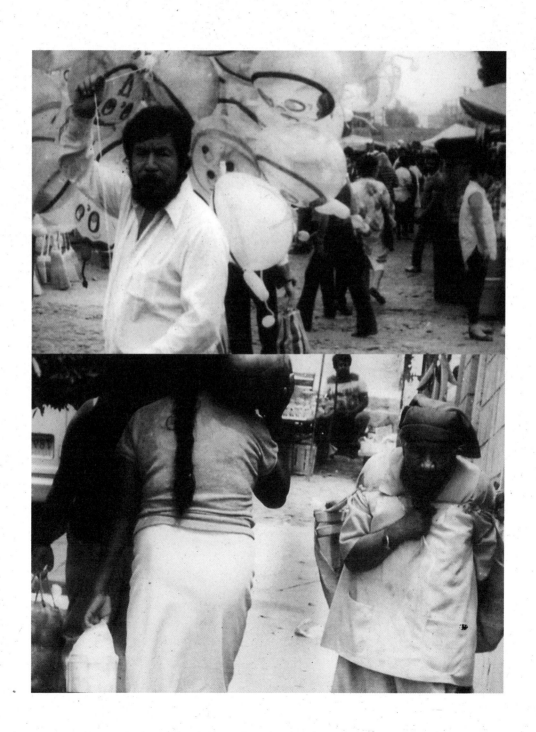

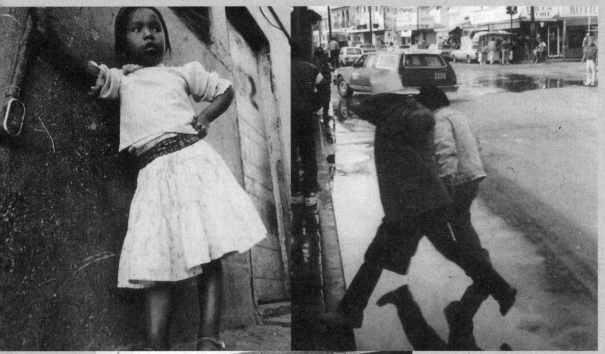

An ethnic scene characterized by: a small population of indigenous natives, a significant population of U.S. origin living along the coast of the peninsula, centers of population of Chinese, Italian, Japanese, and Russian origin, as well as a large component of mixed population from different regions of the country and a recent indigenous migrant population with a sharp rate of increase over the last two decades.

Laura Velasco Ortiz, "Migración indígena y diversidad cultural en Baja California," in *Por las fronteras del Norte. Una aproximación cultural a la frontera México-Estados Unidos*, ed. José Manuel Valenzuela Arce, México: Conaculta, 2001, p. 200.

- In Tijuana 1.4% of the population speak an indigenous language. The most common indigenous language is Mixtec: 32 of every 100 indigenous speakers speak Mixtec.

- Of the population of indigenous speakers, 92.4% also peak Spanish.

- From 1990 to 2000 an increase of 19,508 indigenous speakers was registered in the state, which equates to an annual increase of 7.6%.

XII Censo General de Población y Vivienda, INEGI, 2000.

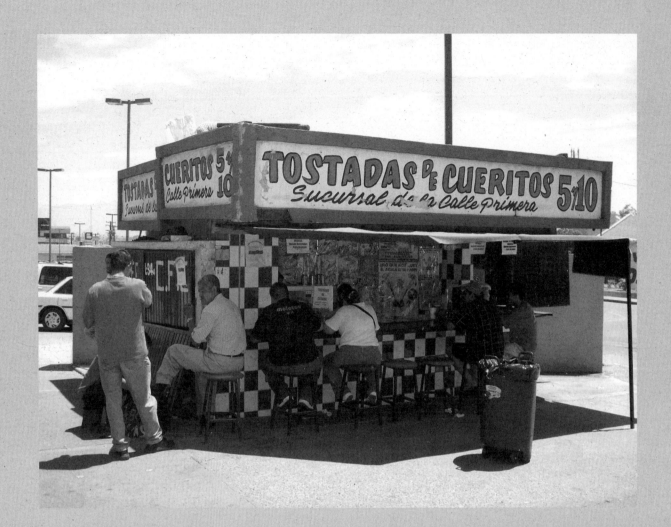

■ One of every three children between 6 and 12 years in Tijuana is obese, according to the Universidad Iberoamericana, which attributes this obesity to the children's bad diet. They are used to eating junk food. Obesity among the children of Tijuana surpasses the national average by 6%.

From Universidad Iberoamericana Plantel Noroeste, 2003 and www.frontera.info

- The social security system (IMSS, ISSSTE, ISSTECALI, SMM) takes care of 55% of the population in Tijuana. The other 45% go to the 23 units of the Secretary of Health and Assistance, and to private doctors.

- The public system is made up of 35 external consultation units and five general hospitals or units of secondary level care.

- Private medical care is under the ownership of 133 hospitals, 800 medical and dental practices, 127 laboratories, and 651 pharmacies.

City Development Plan, 1996–1998, IMPLAN and INEGI, 1996.

- ISSSTE doctors in Tijuana take care of 25 patients by turns in the hospital, can count on more than 30 beds, without taking into account intermediate areas of therapy. ISSSTE reckons with 114,000 legal claimants for services.

www.frontera.info

- Tijuana registers the fewest nuclear homes of the state, with 70.9% of the population. Homes of one to four members represent 60% of the total.

- Of these, 78.6% are headed by males, 21.4% by females.

XII Censo General de Población y Vivienda, INEGI, 2000.

- 33.5% of the urban population is 0 to 14 years of age.

- 62.84% 15 to 64 years of age.

- Only 3.66% are 65 or older.

XII Censo General de Población y Vivienda, INEGI, 2000.

- From 1996 to 2004, the number of women migrants who arrive at this border in search of a better life has grown by more than 400%. The majority of them are mothers and are between 20 and 30 years old. Eight of each ten have completed only the sixth grade.

www.frontera.info

- According to the 2000 Census, Tijuana had a population of 1,210,820 that year. Only 47.9% had a legal claim to some kind of public health care. 18.4% survive on two or fewer minimum-wage salaries. 42.7% have an income of three or fewer minimum-wage salaries, 'and if we take into account the whole of the population with five or fewer minimum-wage salaries, we find 69.3% of the population at this level, which means that more than two-third of the population of Tijuana is below one of the parameters of what is called the poverty line.... As a function of the inflationary level of the city and of the salary levels, a Tijuana family requires at least six minimum-wage salaries to satisfy its basic needs...'

Edgardo Contreras Rodríguez, "El voto de los pobres en Tijuana," in *El Bordo*, magazine no. 8, Universidad Iberoamericana Plantel Noroeste, Tijuana.

- According to the Secretary of Social Development there are more than 19,000 households living in a state of 'poverty' in Tijuana. According to the Tijuana Food Bank (Banati), 260,000 people don't have enough to eat. The majority of persons who are helped by this institution are single mothers, families with more than six children, and the elderly.

www.zetatijuana.com

- In Baja California, 53.3% are classified as Economically Active Population (PEA); the Economically Inactive Population (PEI) represents 43.9%.

- By contrast, at the national level the PEA is 49.3% and the PEI is 50.3%.

- Tijuana registers the highest percentage of PEA in the state: 56.8%.

- 22.2% work more than 48 hours weekly, almost 18 hours more than the national average.

XII Censo General de Población y Vivienda, INEGI, 2000.

▪ 30.4% OF TIJUANA'S POPULATION ARE YOUNGER THAN 15.

XII Censo General de Población y Vivienda, INEGI, 2000.

▪ **90.7% of Tijuana's population of 6 to 14 years of age attends school.**

▪ **20% of the migrants who arrive in the region are younger than 14.**

▪ **Unofficial calculations place the number between 5,000 and 10,000 street children.**

▪ **According to a 2004 study carried out by the municipal DIF (Integrated Family Development, a government agency to protect children, mothers, and families, run by the city), Copladem, and Non-Governmental-Agencies, there are 5,853 child workers in Tijuana.**

▪ **In Mexico City there are, proportionally, fewer street children (14,320 in a population of around 20,000,000).**

▪ **The main neighborhoods where child workers live: Camino Verde, Sanchez Taboada, Obrera, Lomas Taurinas, Francisco Villa, Libertad, Zona Centro, Emiliano Zapata.**

▪ **The main jobs of Tijuana's child workers: Supermarket baggers, chewing gum vendors, newspaper vendors, flower vendors, curio vendors, ice cream vendors, fruit vendors, balloon vendors, snow-cone vendors, candy vendors, fantasy jewelry vendors, churro vendors, car washers, windshield cleaners, trash collectors, shoeshine-boys, singers, bar cleaners, brick-layer helpers, messenger boys, tourist guides.**

INEGI, Demographic Profile of the Child Population in the City of Tijuana and www.jornada.unam.mx

- The services of reproductive health are those most utilized by inhabitants of Tijuana seeking health care in San Diego. For every 100 visits for reproductive health in Mexico, 14 were in the United States. Middle class or upper class women are those who most use reproductive healthcare services. The majority of these women go for these services so that their children will one day achieve U.S. citizenship.

Martínez Canizales, El Colef/Guendelman y Jasís, 1991.

- In 1990, of every 100,000 women older than 15 years, 16 died of uterine cervical cancer. In 1991 it goes down to 14 deaths per 100,000. In 1994, the number goes up to 17.04.

- Of the total deaths between 1995 and 1997 only 15.8% had reached an educational level higher than primary school.

Martínez Canizales, El Colef.

- In Tijuana, 1.2% of the total population has some kind of incapacity.

- The most common incapacity is motor (55.7%), then visual (16.3%) and mental (17.6%).

XII Censo General de Población y Vivienda, INEGI, 2000.

■ IN **2000** THERE WERE **492** PRIMARY SCHOOLS AND **152** SECONDARY SCHOOLS IN TIJUANA.

Rotary Club of Tijuana, 2000.

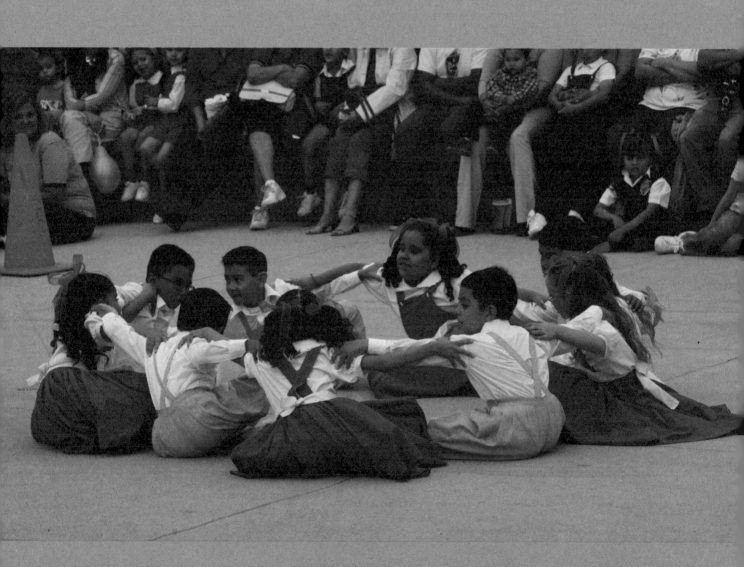

The main prep school in the city is Preparatoria Federal Lázaro Cárdenas, founded in 1946. In 1949 it moved its operations to the expropriated site of the Agua Caliente Casino.

David Piñera Ramírez, *Historia de Tijuana. Semblanza General*, Tijuana: Centro de Investigaciones Históricas UNAM–UABC, 1985.

- There are 25 public libraries in Tijuana.

- In the 2004 local telephone book there were 68 bookstores.

From Instituto Municipal de Arte y Cultura and the Tijuana phonebook, 2003.

- 11.9% of the population older than 18 years has a high school education.

- Of every 100 professionals, 93 have completed a college degree and only seven a master's or doctorate.

- Of the population with postgraduate training, 41.5% are women.

XII Censo General de Población y Vivienda, INEGI, 2000.

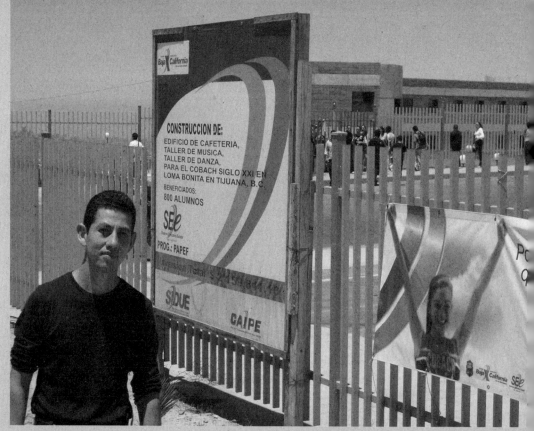

Ramsés is 23 years old. He is in the third semester of prep school, at Cobach Siglo XXI, the lowest grade level in the state.

The preparatory school was constructed on a full municipal dump. When it gets hot, the students say it stinks. A teacher who teaches ethics in the first semester, philosophy in the third, and Greek and Latin etymology in the fifth, says that "although we're on garbage, we have to keep on struggling." More than 60% of the students are of the lower class.

Teachers make 56 pesos per class hour.

Ramsés rented a yellow cab and took passengers towards the United States or picked up tourists at the line. He decided to go to school to "get ahead." His favorite subject is Mexican history.

"The transmission dropped out of the cab, and the taxi owner's wanted me to pay for it." Then he went to work at Formosa, an assembly plant that assembles for Panasonic, JVC, and Sony. There he makes 450 pesos a week (less than $45).

Ramsés works the swing shift. The assembly plant bus goes by the entrance to the school at 1 p.m. and drops off the students who work assembling in the morning and picks up those who assemble in the afternoon. Many students have been contracted by the maquilas.

For the philosophy professor, this situation is demoralizing. "You teach them so that they won't end up in the assembly plant, but the class is hardly over when the factory bus picks them up." He remembers that he was a Marxist at the university and worked assembling at Verbatim, an assembly plant built in front of the Autonomous University of Baja California, but then he read Baudrillard and now he isn't so sure "if the struggle is worth the trouble." Ramsés, he says, has been one of his favorite students.

Ramsés doesn't want to work in the assembly plant any more. On weekends he makes $70 as a gardener in San Diego and has just had a job interview with a factory from India, he says, where he would make 3,500 pesos every two weeks translating from English to Spanish and from Spanish to English.

He defines Tijuana as "a big mess." But he says that he likes Tijuana. "All cities are a mess. But none reflect the mess more than Tijuana."

The philosophy teacher says he agrees with Ramsés. But he adds that for him "Tijuana is an urban mix of frustrations and hopes"; for him "Tijuana is Ramsés."

Interview, Tijuana, 2003.

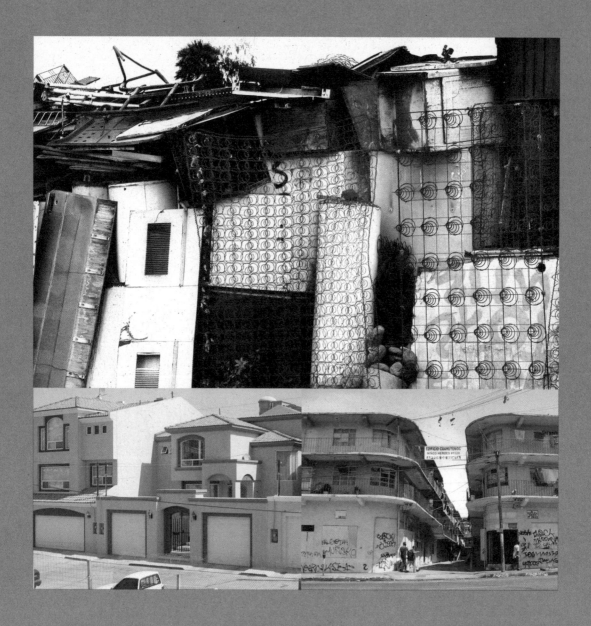

■ According to Silvia Lopez Estrada and Gerardo Ordoñez Barba,
researchers at Colef, in 2000 there were 466,800 persons in Tijuana
living in conditions of poverty. 13.2% of Tijuana households were
found in conditions of poverty with regard to food; 17.2% on the
threshold of developing capacity; and 34.5% on the threshold of
developing the ability to have properties.

From *Zeta* and El Colef, 2004.

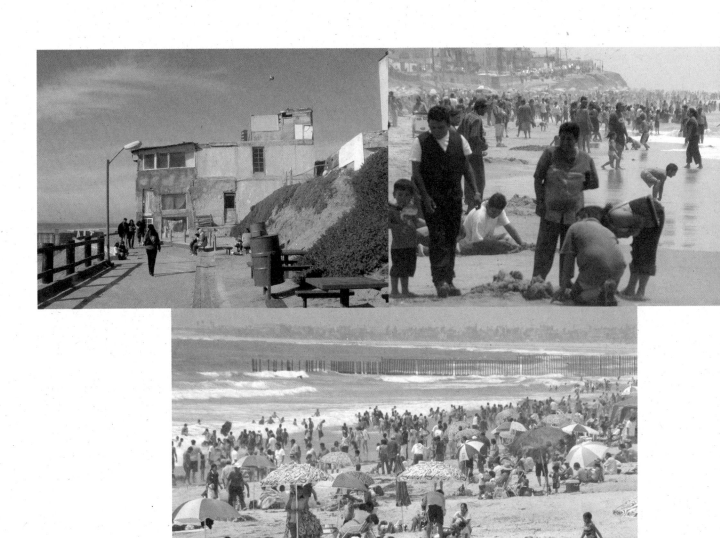

We Tijuanans cannot depend on a multinational company for the treatment and supply (of water). Our Government should have control of this resource and look for more viable solutions so that the water is for everyone, and so that in the future (the concessions that the gas companies are seeking to obtain will be for a period of 30–45 years), when the world water crisis is an emergency, we Tijuanans can obtain it, and its use won't be conditioned and much less for exclusive use for the cooling of the turbines of the energy generators of Marathon Oil, since the main reason for which Marathon offers to treat the water of Tijuana is because it needs it for its turbines.

Letter by Neighbors from Playas of Tijuana, Monday, August 25, 2003, 10:02 a.m.

" **TIJUANA IS NOT MEXICO.** "

Raymond Chandler, *The Long Goodbye*, Boston:
Houghton Mifflin Co., 1953, p. 27.

20 SYMPTOMS THAT YOU ARE A TIJUANAN:

1. You go down Agua Caliente Boulevard and you are the only one who is not a bus or cab driver.

2. Your favorite place to drink is in a car parked on La Chapu [short for La Chapultepec, a neighborhood in Tijuana where the rich live].

3. You know that the 5 & 10 Intersection [named after the 5 & 10 Cent Store, no longer there] doesn't cross either 5th Street or 10th Street.

4. For you, everyone who likes soccer is from Mexico City.

5. You call everyone bro, bato, or wey.

6. Guys (Morros) are those under 15, but EVERY woman can be your chick (morra).

7. Going abroad doesn't affect you much one way or another.

8. Disneyland is not such a big deal.

9. Your image of hell is Mexicali.

10. Someone in your family suffered Ruffomania [pro-Ruffo, the first opposition governor of Baja California].

11. The term "The Ball" [Bola in Mexico also means "the People"] has no popular connotation... it merely means Cecut [Cultural Center of Tijuana, housed in a spherical structure].

12. 90% of the money in your wallet is dollars and 10% is tips.

13. You have worked at least one weekend at some Swap Meet.

14. You earn more than any other wey in the country, but you go on whining anyway.

15. You lost your anal virginity at the Port of Entry during secondary inspection.

16. Beyond Mexicali everything is Mexico-City Land.

17. You know that Tijuana is the city with the most inflated statistics in the world.

18. The "Bolero" is not only he who cleans shoes [but also a strip joint in Tijuana famous for its beautiful girls].

19. You always gas up on the Other Side [U.S.] and believe that Magna Sin (a Mexican brand name) gas is adulterated.

20. You know that there is no second Tijuana and if there were one, the drug dealers would already have killed it.

Email forward.

IN 1990, 87.3% OF TIJUANANS WERE CATHOLIC.

XII Censo General de Población y Vivienda, INEGI, 2000.

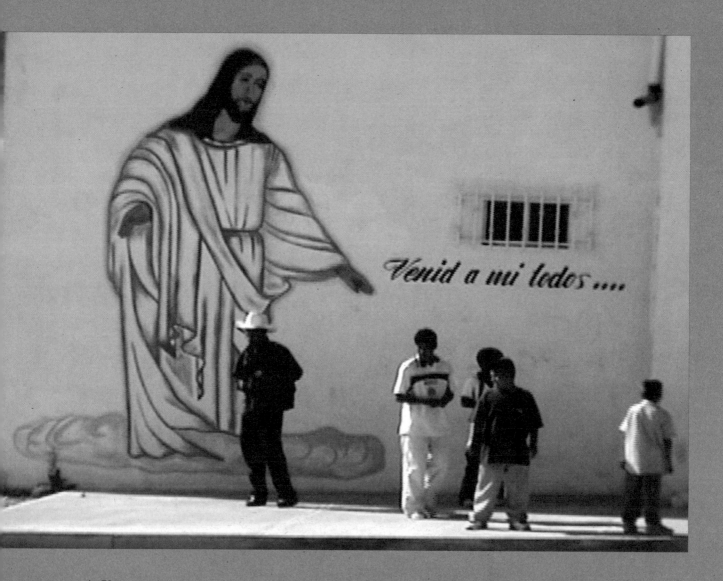

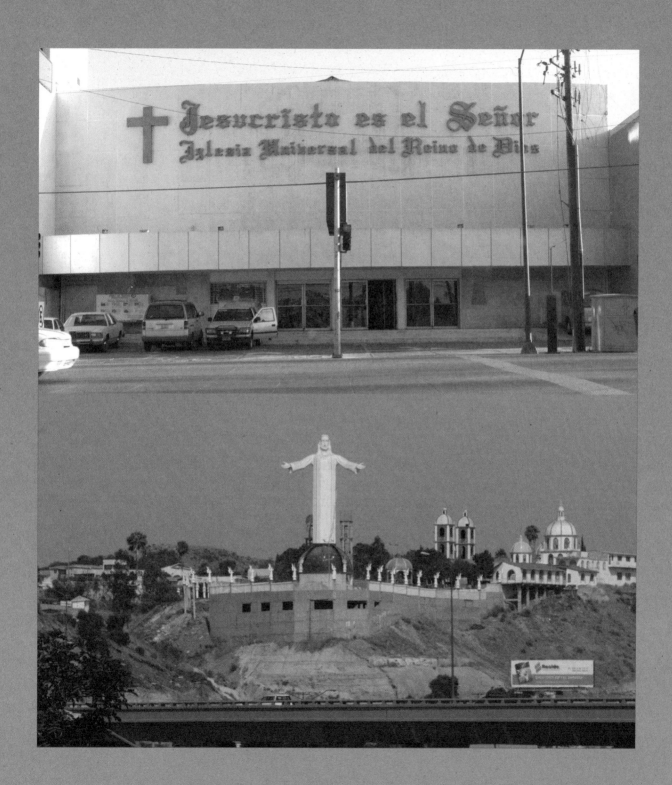

- In 1950, there were 31 priests for 285,000 Catholics in the city, of a total of 300,000 residents. In 2002, there were 215 priests for 2,631,377 Catholics of the total of 2,894,514 in Tijuana, according to the data of the Diocese of Tijuana.

www.iglesiatijuana.org

- In 1987, there were 322 non-Catholic religious societies in Tijuana, among which stood out the Pentecostals. 4.95% of the Tijuanan population declared themselves Protestant.

www.inegi.gob.mx

- According to the National Institute of Statistics, Geography, and Information (INEGI), Catholicism in Tijuana went from 90.3% in 1980 to 82.19% in 2000. The national percentage is 88%.

- According to the 2000 Census, 82.19% of Tijuanans profess the Catholic religion; 7.41% are Protestants; 3.07% follow a non-evangelical religion; 0.03% are Jews; 0.31% practice other religions; and 5.30% have no religion, while 1.69% did not specify if they were followers of some belief.

www.inegi.gob.mx

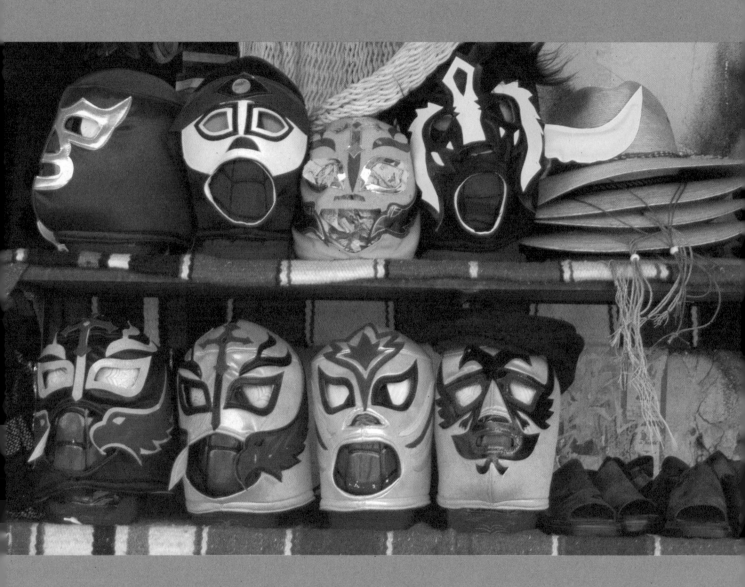

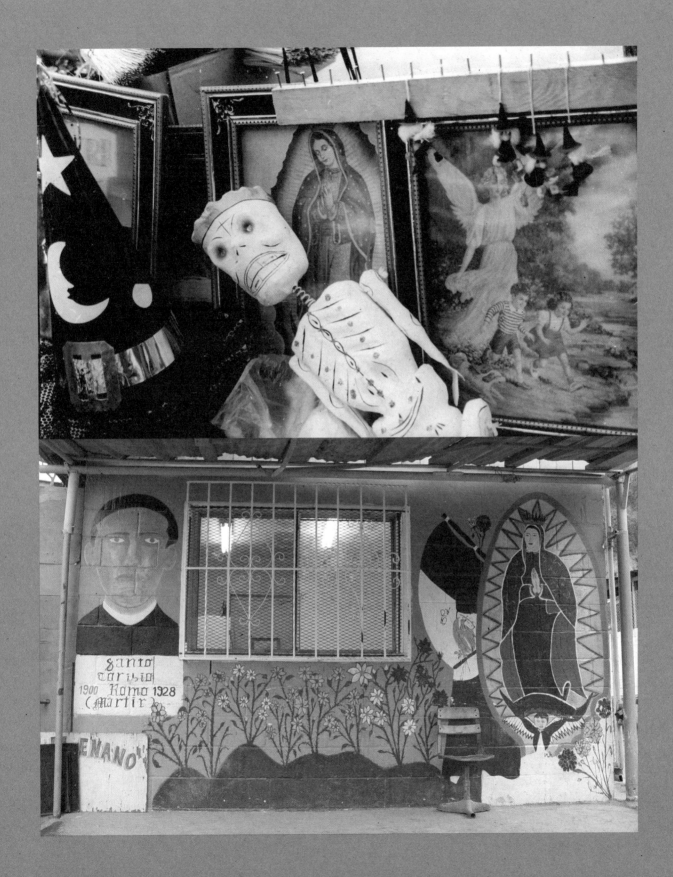

" NOW THE COUNTRY HAS BECOME TIJUANIZED; THE TRUE TWENTY-FIRST CENTURY, SO SOUGHT AFTER, THAT ARRIVED TO TIJUANA BEFOREHAND, IS ALREADY IN THE NATIONAL TERRITORY WITH THE EVIL BURDEN OF THE GLOBAL VILLAGE. "

Jorge Ruiz Dueñas, "Pequeña crónica de una nostalgia" in *Equis* magazine, no. 9, México, January 1999, p. 17.

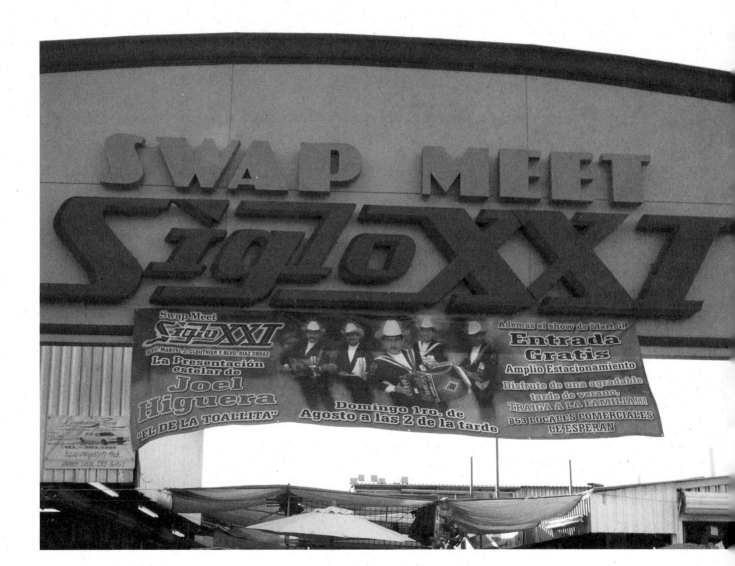

ESTETICA UNISEX

PRADA

ALACIADOS

CORTES TINTES FACIALES

EXTENSIONES

UÑAS RAYOS DEPILACIONES MECHONES

MANICURE PEINADOS

DECOLORACION

PEDICURE

PERMANENTE MAQUILLAJE

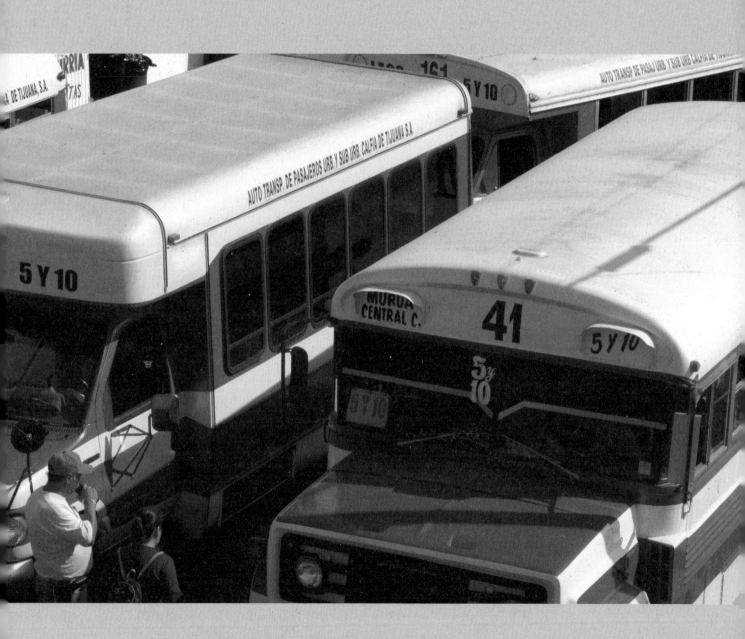

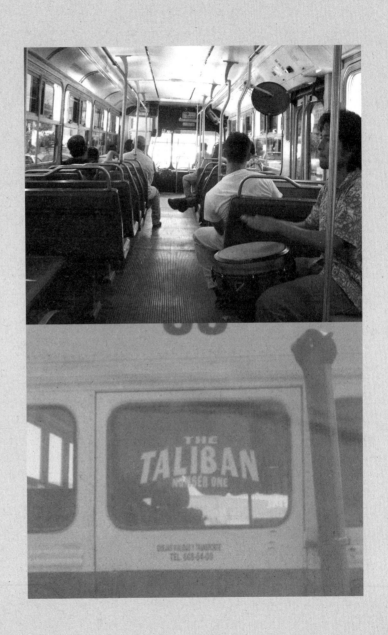

Federico López, driver of a Taxi Libre (no set route) pays 400 to 600 pesos to rent a unit. He picks his passengers by checking them out; among those hailing him there are many dangerous vagrants, he says.

He charges 25 pesos to take a Mexican from the border line to Revolution Avenue. And when North American "idiots" don't know the difference between pesos and dollars on the meter, he charges them $25.

For the same ride, yellow cabs (set route) charge $5 to take someone and $3 per person when more than one ride.

Some people prefer Taxis Libres because they are fast and cheap; for example, many ladies with their shopping take them.

Federico spends 400 pesos a day on gasoline. These units are old models, 1997 the newest.

To get plates for these cabs costs between $9,000 and $10,000. But plates can be rented for 3,000 pesos a month.

In 2004 there were 3,000 Taxis Libres in Tijuana.

Cab drivers on set routes have always been opposed to this kind of service. Taxis with set routes are collective vehicles; in 2004 the fare was generally about seven pesos.

Their passengers are students, families from low to middle class and all kinds of employees. In these cabs, sometimes, the people talk among themselves and the drivers almost always play music, from hip hop to corridos, or they listen to talk radio.

Teresa Gomez, who works at the phone company, doesn't like them because the collective taxis "go very fast."

Ricardo Zenteno charges two fares to fat passengers, and if a passenger pays him with a 200 peso or 500 peso bill, he gives change in small coins to get rid of the "bastard." He likes big-band Mexican music.

The most popular collective taxis are the red and black ones that cover the pre-established route from the city center, via boulevard, to Clínica 27 or La Presa. It takes between 40 minutes and an hour to cover the route.

Up to nine people can ride in these taxis.

Interview, 2004.

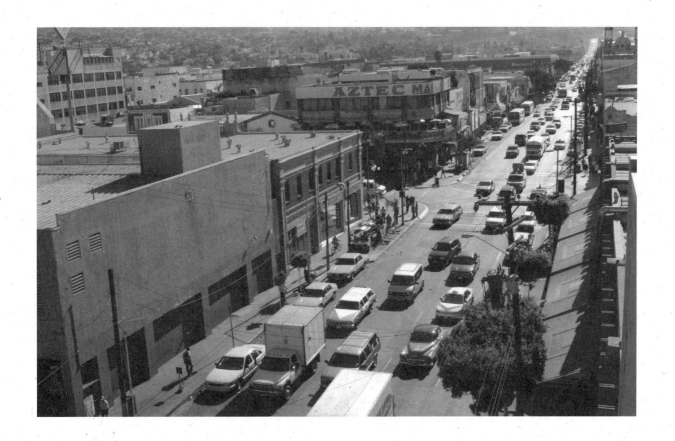

" AT THE BEGINNING OF THE **1920s**, PUBLIC TRANSPORTATION
TO ACCESS TIJUANA AND THE TAXIS WAS COMPLETELY IN THE
HANDS OF UNITED STATES CITIZENS... IN **1925** RACE TRACK
WORKERS STAGED A WORK STRIKE, COMPLAINING THAT THE
JOBS THERE SHOULD BE FOR MEXICANS. THEY WERE ABLE
TO NEGOTIATE THIS POINT, OBTAINING **60%** OF THE JOBS. "

Jorge A. Bustamante, *Historia de la colonia Libertad*, Tijuana: El Colef, 1990, pp. 11–12.

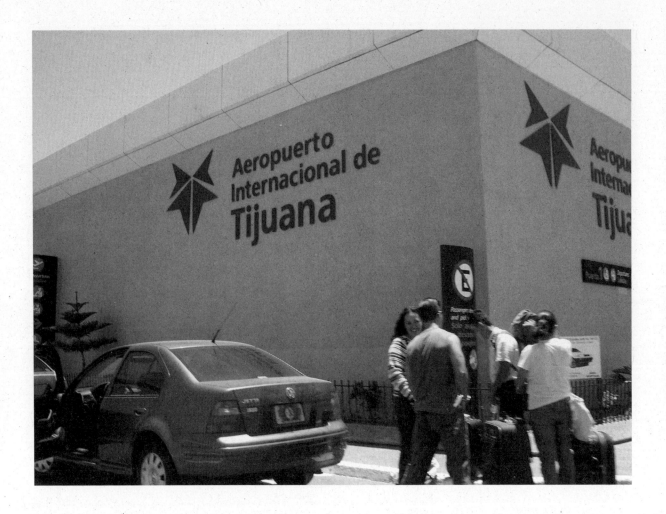

■ According to the Department of Operations of the Tijuana Airport, in the month of July, 2000, there was a total of 309,138 passengers in the airport of Tijuana; in July, 2003, 360,084.

■ In these same months and years, 88,286 and 84,421 passengers, respectively, used the Central Bus Depot, according to the Business Office of the Central Bus Depot of Tijuana.

■ The Immigration and Naturalization Service of the United States reported that in the month of July, 2002, there was a total of 7,503,861 border crossings through the two gates (San Ysidro and Otay). Of these, 2,019,473 were pedestrians, 2,680,532 were foreigners, and 2,803,856 were vehicles.

www.frontera.info

- Baja California is the Mexican state with the highest percentage of urban population (91.6%). Tijuana, the city with the most urban population. Only 1.2% of its population lives in rural areas.

- The 1990 Census tells us that 51% of the state's population is native, 45% were born in other states, and 2.4% in another country. In contrast, the national average of population born in other states is 20%.

- 40% of the city's migrant population comes from Sinaloa, Jalisco, and Sonora.

- Of every 100 males of five years or older, 13 resided outside the state in 1995.

- The principal reason men come is work; for women, it's to join their families.

- Of every 100 persons who emigrate from Baja California to another country, 95 go to the United States.

www.inegi.gob.mx

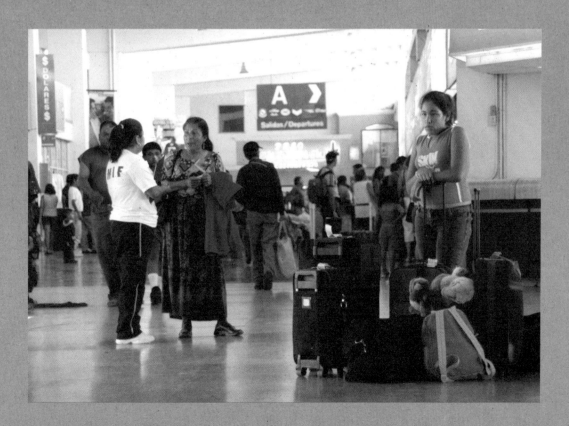

AGUA CALIENTE RACE TRACK

On January 1, 1916, the first race track in Tijuana was inaugurated. It was located 150 meters from the international crossing, but its ephemeral existence lasted not even two weeks. This same year – December 28 – another facility was constructed where the current River Zone is. This racing center would be substituted in 1929 by the Agua Caliente Race Track, first component of the tourist casino complex.

'For many years the Agua Caliente Race Track was run by Johnny Alessio as front man. As Al Capone and Charlie Lucky Luciana had done in the United States, Alessio brought about in Tijuana a State within another State as an infallible formula for the managing of this world ruled by special codes,' wrote Rod Silica in *The True History of the Mafia*.

The Agua Caliente Race Track continued its operations until August 5, 1971, when a fire leveled most of the buildings

From May 4, 1974, until May 17, 1992, the track was again operating, when its concessionaire – Jorge Hank Rhon – closed it because of a workers' strike and to declare that the trace track was no longer in business.

For years, there have been fairs, concerts, and other kinds of events on its grounds.

Hank Rhon's concession ends in 2011.

La crisis magazine. "Voz de la Calle. Negocios sucios de Jorge Hank Rhon," www.lacrisis.com.mx, 2003 and David Piñera y Jesús Ortiz, *Historia de Tijuana. Semblanza General*, Centro de Investigaciones Históricas UNAM–UABC, Tijuana, 1985.

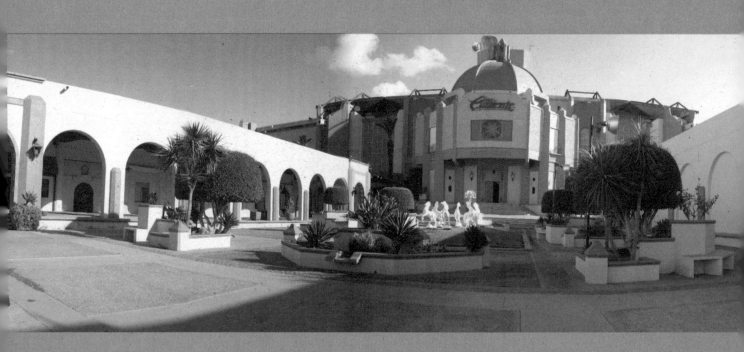

" **IN BAJA CALIFORNIA TIJUANA AWAITS YOU.** "

Local television slogan by Singer Ricardo Ceratto.

QUESTIONS TO THE READER OF TODAY AND OF THE FUTURE

Do you believe the Tia Juana Ranch was the first settlement of European families in the Tijuana Valley?

According to Mr. Raziel de Lugo D., an old resident of this city, Tia Juana merits a monument to her memory here or in the United States, since the Tia Juana Ranch divides the Border Line in two. What do you think?

Would you approve of the Santa Cecilia Plaza being named the Tia Juana Plaza... and a monument being erected in this spot?

Do you know why the name 'Tia Juana' was changed to 'Tijuana?'

It's very simple. Because our neighbors in the United States, in the old days and still now, write the name thus: T. Juana and if the T in English is pronounced (tee) it's clear... Ti Juana, no?

Maybe all this stirs up negative ironies, but it so happens that to negate is very easy; to prove the contrary is the hard thing, don't you think?

After the publication of my book *Stories and Legends of Tijuana* many more versions of these themes emerged. How many versions of Tia Juana will be written after mine?

Let's wait...

Olga Vicenta Díaz Castro, "Sor Abeja," *Narraciones y leyendas de Tijuana*, Tijuana: Instituto Tecnológico de Tijuana, 1990, p. 117.

DESIRES

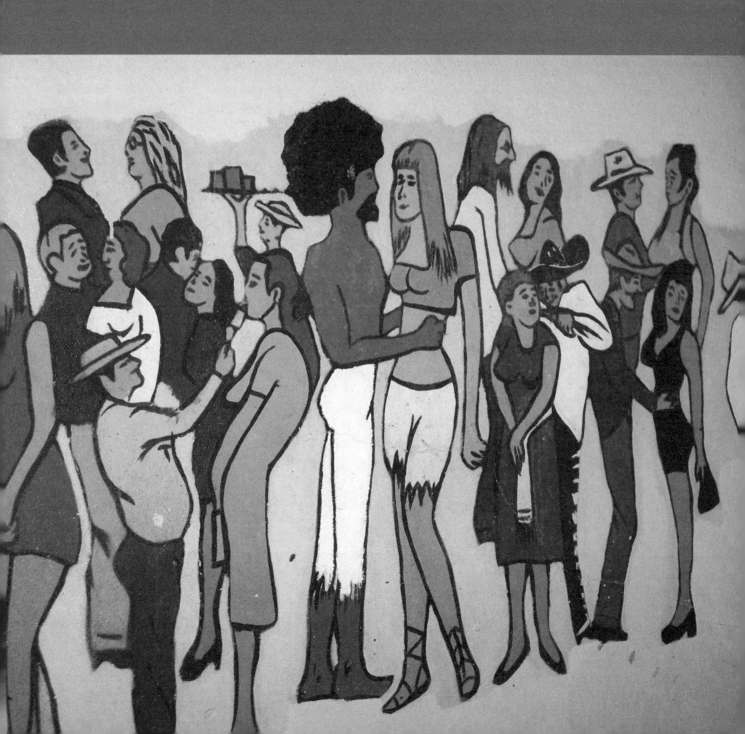

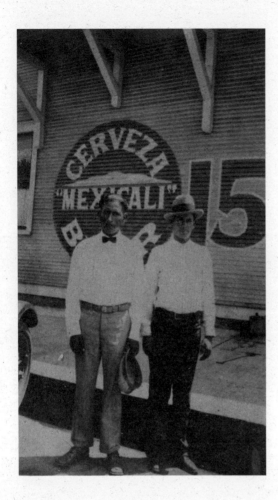

Even before the abrupt appearance of Prohibition in the United States in the 1920s, games of chance and betting had already been regulated in Tijuana since 1908, although at the petition of the North American government the permits were revoked in order to slow down attracting undesirable subjects to the region.

'Gambling houses again emerged in Tijuana in 1911, during the revolt headed by Ricardo Flores Magon and the Mexican Liberal Party.... After the taking of the town on the morning of May 9, 1911, by the Second Division of the so-called "Liberal Army," its commander, the "general" Caryl Ap Rhys Pryce, tried to promote tourism in the town with the proposal of bringing together money to buy arms,' writes Lawrence D. Taylor ("Los casinos y el desarrollo de la ciudad de Tijuana, 1908–1911").

During the 1920s increasing numbers of bars, night centers, liquor dispensaries, and casinos appeared not only in Tijuana but all along the border. From this period we recall La Ballena Bar, whose bar of 170 meters in length was announced as the longest in the world. Owing to the 'touristic' development, Tijuana went from 1,028 inhabitants in 1920 to 8,384 in 1930.

There were several casinos that operated during this period. The most famous was Agua Caliente, whose hotel had 500 rooms in the colonial California style, a radio station, restaurants, golf courses, an airport, swimming pools, gardens, dining rooms, and a garage for 50 automobiles.

But in the middle of the 1930s, the Mexican president Lázaro Cárdenas seized the Agua Caliente Casino and prohibited games of chance.

According to Jorge A. Bustamante, the fleeing entrepreneurs of casinos in Baja California were the same people who opened the first casinos in Las Vegas.

David Piñera Ramírez, *Historia de Tijuana*. Semblanza General, Tijuana: Centro de Investigaciones Históricas UNAM–UABC, 1985.

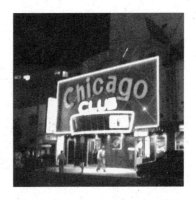

The Red Zone, Zone of Tolerance, or Northern Zone of Tijuana runs by very close to Coahuila Street, 300 meters from the international line and a block from the Tijuana Cathedral, the old Municipal Palace – now the seat of the Municipal Institute of Culture and Art. It extends for several blocks, and in addition to cantinas, the district is populated by motels, liquor stores, dives, restaurants, food joints, bars, repair shops, homes, rehab centers, little drug stores, evangelical temples.

The bars are of a distinct kind. They are for the low class, such as The Quincle or The Infierno; for gays, such as The Taurino, or those dedicated to providing attractive and numerous sex workers, such as The Adelita or The Chicago Bar.

The district is commonly known as 'The Coahuila' and to go to drink, to enter into its dumps, to eat tacos, or to pay for sex is referred to as taking a 'Coahuilazo' (a 'whack by Coahuila') or to 'Coaguilear' ('to Coahuilize').

The people who work in its bars and streets call it 'The Zone.'

Interviews, 2004.

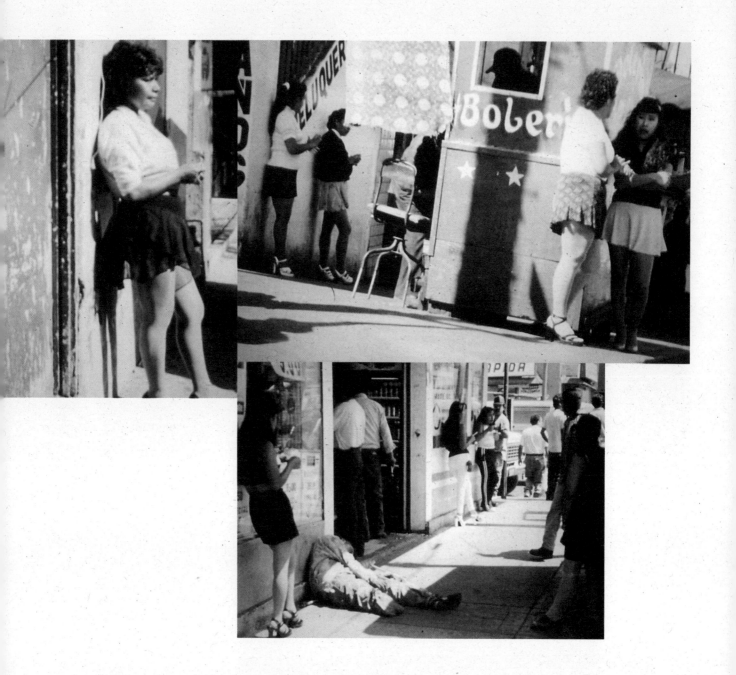

"
HOW ARE MOST OF YOUR CLIENTS?
UGLY, THEY STINK, AND THEY WANT YOU TO BLOW THEM. "

Maria, prostitute on a public street in the Northern Zone, Tijuana, 2004. She charges 75 pesos.

Many women took advantage of paying jobs in the service sector. Imagine how a
 young girl (some recently arrived from a rural district of interior Mexico)
 felt as a hatcheck girl in a glamorous casino, or as a waitress in a fancy
 restaurant, or selling French perfume along with cashmere scarves. Making
 beds and washing laundry day after day might be back-breaking routines,
 but for many it must have beat hoeing weeds in a parched field or sweeping
 animal mess from a dirt floor. Besides, urban life itself had its excitement,
 then as today.

 Paul J. Vanderwood, *Juan Soldado. Rapist, Murderer, Martyr, Saint*, Durham and London: Duke
 University Press, 2004, pp. 111–112.

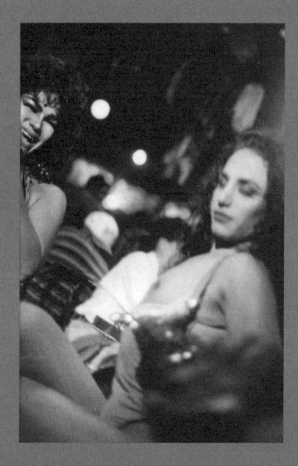

" ... OPEN 69 HOURS A DAY TO SERVE YOU, PROSTITUTION AND VICE. "

Parménides García Saldaña, *Pasto verde*, Mexico: Diógenes, 1968, p. 11.

■ IN 2003 THE CITY OF TIJUANA HAD 13,340 SEX WORKERS REGISTERED IN ITS SYSTEM OF HYGIENE CARDS.

Jesus Gonzalez Reyes, Second State of the City Address, Tijuana, 2003.

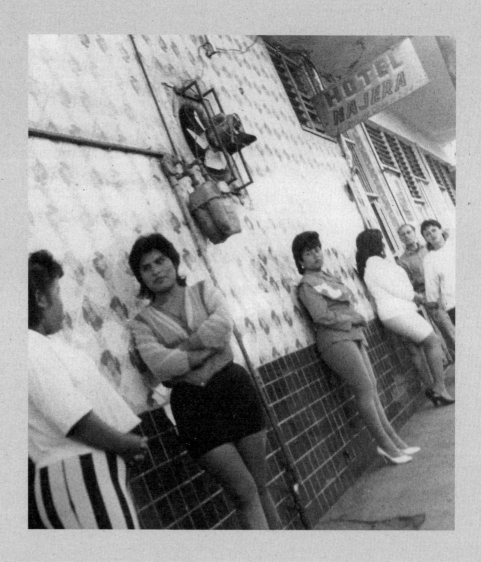

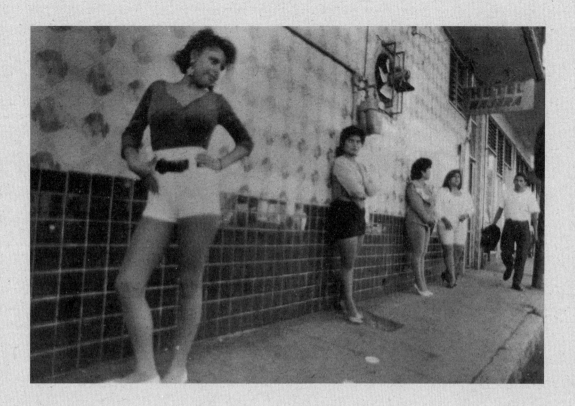

- Each year 50,000 women and children are trafficked illegally to the United States for prostitution. The Tijuana-San Diego region is one of the main corridors of this traffic.

- At least 900 minors prostitute themselves in Tijuana.

- A significant part of the business involves the Internet.

- In testimony, the children pointed to the municipal police as procurers of clients, in exchange for 50% of the payment.

- 'Trick' (boy masturbating a client): $20.

- Boy giving the client oral sex: $50

- Client giving anal sex (male) to the boy: 100.

- Client giving anal sex (male) to the boy (without condom): $180

- Vaginal sex with a 'Cherry Girl' (virgin): $500.

www.jornada.unam.mx

THE ADELITA BAR Noisy, crowded, hot and loud, the Adelita Bar is pure South of the Border. The second you step inside, you'll be greeted with sights, sounds and smells that are all Mexican. By Zona Norte standards, the interior of the Adelita Bar is quite lavish. Music comes from a DJ and it tends toward Tejano, Conjunto and Norte. There is ample seating and they usually have soccer or some other sports on T.V. (like you go there to watch the game. Not!). Beer or a tequila shot is currently priced at about $1.75. At those prices, you can afford to give your bartender or waiter a $1 tip per round. If you do, you will receive cheerful and efficient service unknown in los Estados Unidos. Like the other Zona Norte clubs, the Adelita Bar works on the dance hall format. So there are two dance floors in pretty constant use by the Mexican guys and the girls. Some nights, they will sometimes have a few of the girls do a short strip show on the front stage. It's nothing spectacular.

On a typical weekend night, you'll find at least 50 girls to choose from. So if you're patient, you can find somebody that appeals to you. Look for the young, quiet one hiding in a corner and indulge your high-school girl fantasy. Or go for the hard-bodied girl with the golden skin and the skin-tight minidress. Best of all possible finds is the truly gorgeous young thing just starting out. Sometimes, these girls start at the Adelita Bar before moving on to the more upscale Chicago Club.

I've found if you keep smiling and talking, your hands can roam a little and the girl won't mind. This of course is the reason you're in the Zona Roja: to get away with doing things that would get you slapped anywhere else. The girls' English ranges from pretty good, to virtually non-existent. But don't let the language barrier keep you from the girl of your dreams.

If you seem to like her, she will ask you if you'd like to 'go to the room,' or 'go to the hotel' which is their euphemism for doing business. If you say yes, she'll quote you a price, generally $40-60. If you are quoted more, the girl has sized you up as a gullible tourist. Politely counteroffer, keeping in mind that once you get to the hotel you will be required to pay an additional $10 for the use of the room for 30 minutes.

Don't be embarrassed about haggling. Amiable negotiation is practically a national sport in Mexico and the commercial sex trade is the whole purpose of the Zona Norte.

www.worldsexguide.org/tijuana_faq.txt.html

Nirvana is 21 years old. She was born in Acapulco. She has been in Tijuana two months. She works
 in Adelitas. She doesn't know the city but says that she has been treated well. She says that
 all her girlfriends are from Mexico City, Acapulco, Oaxaca, Guadalajara. None from Tijuana.

To go to a hotel with her for 30 minutes costs $60, plus $11 for the room. She provides
 the condom.

She doesn't do any other kind of sex. If someone "wants it from behind I tell him he better
 go to the Noa Noa. There are a lot of queers there that he can stick it in."

Every 15 days she has a vaginal exam and an AIDS test. Nirvana's motto is, "With soap and
 water you erase the footprints of any idiot.

Interview, 2004.

The discourse on Tijuanan immorality has, in effect, an ideological dimension
that goes beyond local circumstances to inscribe itself within a broader
dimension: the traditional image of Tijuana is also an interiorized form of
cultural otherness, a radical manifestation of the 'other'.... Tijuana has
come to represent the emblem of social violence with no control
whatsoever.... The city is thought of as a decomposing, rotting body...
[it is a] metaphor of the border par excellence or as the epitome of urban
evil.... The circle has closed: from analogy to metaphor, and to symbol.
What one day began as a metaphorical comparison ('Tijuana is like
Babylon')... with time changed to its transformation into a symbol open to
the signification ('X is like Tijuana'). The signified 'Tijuana' is now a signifier
of another signified.... Lacking a grandiose past, a promising future is
invented.... From the 'black legend' to the 'legend of light,' without doubt.
The fate of a utopia shaped, in large measure, by the groups with economic
power... [who] have assumed the task of getting rid of the negative image
of Tijuana, so they can increase the amount of foreign investment.

Humberto Félix Berumen, *Tijuana la horrible. Entre la historia y el mito*, Tijuana: El Colef/Librería El Día,
2003, pp. 129, 319, 342, 346, 361–362.

" HE MANAGED TO MEET A CERTAIN KNOW-IT-ALL YOUTH NAMED BOB TAKASHI... AND TOOK HIM ON A SIX-DAY SPREE IN MEXICO; ALCOHOL, WOMEN, DOG RACES, AND A TEARFUL GOODBYE AT THE BORDER WITH OLD BOB QUICKLY TAKING THE ROAD SOUTH, A FOREIGNER WITH ALMOND-SHAPED EYES IN A WORLD OF ROUND EYES. "

James Ellroy, *The Big Nowhere*, New York: Mysterious Press, 1989.

- IN THE BARS OF THE NORTHERN ZONE A 'JOINT' OF MARIJUANA CAN COST 20 PESOS AND A GRAM OF COKE 100.

- THE PRICE OF SYNTHETIC DRUGS, SUCH AS ICE AND CRYSTAL, HAS COME DOWN IN RECENT YEARS, BY AS MUCH AS 15% OR 20%.

- A BALLOON OF CRYSTAL CAN COST UP TO $2 OR $3.

Interview, 2004.

The Zacazonapan cantina is located one block from Revolution Avenue... some people know the place as the 'Consulate of Amsterdam.' Crystal, marijuana, heroin, cocaine are drugs that can be acquired and consumed with great ease in this place. Nevertheless, the manager likes to presume that the Zacazonapan is known by many people because it has the best selection of music from the 1980s.

Hernández H. Alberto, "Hijos de la madrugada: antros y vida nocturna de Tijuana," *Ciudades*, no. 58, p. 19.

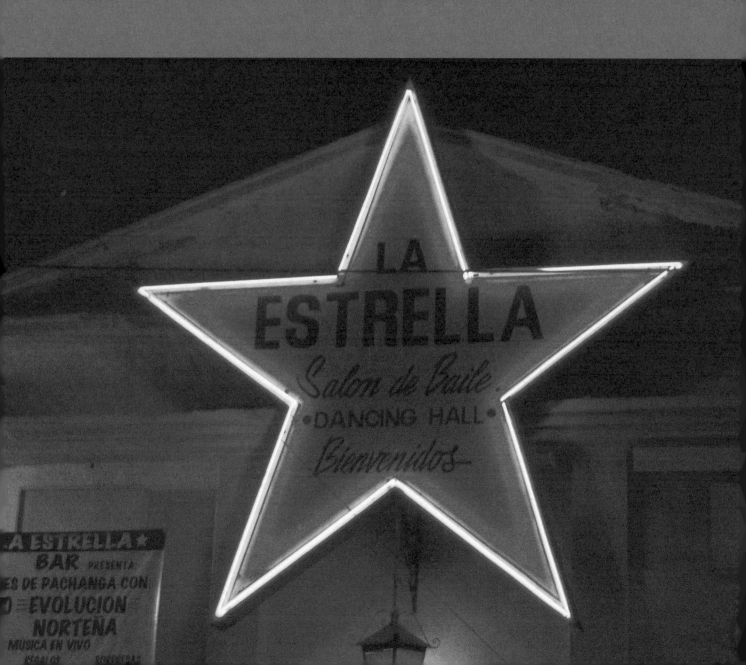

Sometimes, when I am very drunkie, I listen to music to know where I am. If I see three blonde girls dancing at Nek on the table, I know I am in the Pueblo Amigo. If no matter how much I try I can't make anything out, all is a mix of Soda Stereo/Beck/Shakira/Rolling Stones/Molotov, etc., it's obvious I'm in the Plaza Fiesta. If everywhere I see low lifers and well-groomed people dancing the 'Me so horny,' I'm in the Revolution. If I hear Saint Etienne, Spiritualized, Panorama, or Wu Tang Clan and a poster of Andre The Giant greets me uneasily, Jeez! once more I got drunk without leaving the house.

Rafa Saavedra, "Drinking in Tijuana," *Swenga a Lele*, 1999.

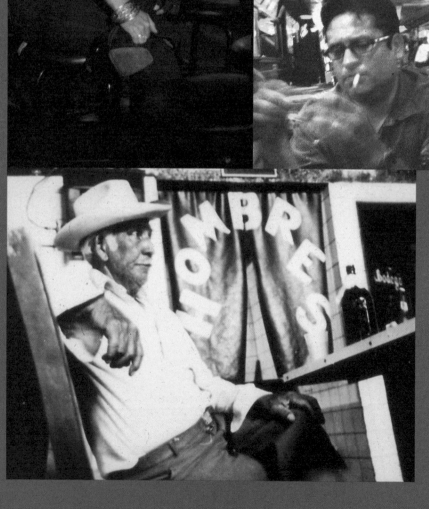

- In information acquired during 2001, as much as **73.3%** of those surveyed confessed to having left their jobs due to "job dissatisfaction."

- This same year unemployment in the city was **0.7%**.

- **45%** of them worked in industry.

www.inegi.gob.mx

DANDY DEL SUR

CERVEZA Sol ESPECIAL XXX Cantina Tecate BEER

AIRE ACONDICIONADO

"IF YOU ARE A BRICKLAYER WHO BREAKFASTS ON DING DONGS
AND SODA AND ANXIOUSLY AWAITS PAYDAY TO BUY YOUR ALARMA
AND YOUR KALIMAN [COMIC STRIP CHARACTER] AND HAVE SOME
TEQUILAS IN THE NORTHERN ZONE, PASS ON, PASS ON."

Roberto Castillo, "La última función del mago de los espejos," in *La pasión de Angélica según el Johnny Tecate*, Tijuana:
Centro Cultural Tijuana, 1996, p. 25.

We asked a waitress from La Estrella dance hall, which is the most representative
 music in Tijuana, and she answers, "What kind of a question is that? C'mon!
 Norteña music. Now... there is 'norteña music' and there is NORTEÑA music.
 It's not all the same."

Inteview, 2004.

■ According to a survey carried out throughout Mexico, published by the local newspaper *Frontera* in 2004, the 'happiest' city in the Republic is Tijuana.

www.frontera.info

■ According to the Municipal Anti-Addiction Department, in 2005 Tijuana had 100,000 drug addicts.

www.frontera.info

“ WELCOME TO TIJUANA, TEQUILA, SEX, MARIJUANA
WELCOME MY FATE, WELCOME DEATH. „

Manu Chao, "Welcome to Tijuana", *Clandestino*, 1998.

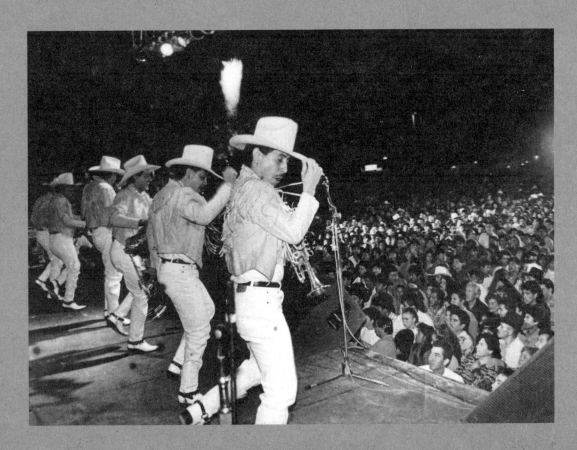

Certainly before the Revolution... there were more whore houses than editorial houses in Havana and not a few higher-class bordellos.... But the same can be said of the Manhattan of our days (or of our nights) where taking a stroll down Broadway (or seeing *Taxi Driver*) one runs into more whores than poets in New York and sees more cute boys than butts of editors seated awaiting unpublished writers. All said (no harm intended) without wanting to establish comparisons, which are odious. But if things are thus in the metropolis, members of the jury, what would not happen, I repeat, what would not happen in the colonies, from Santo Domingo to Santiago, Chile! One must keep in mind, moreover, that Havana was the city of the continent that Columbus discovered (and the Pinzones brothers) closest to the urban area of the U.S.A. – at least if you want to insult Tijuana by calling it a city.

Guillermo Cabrera Infante, "Mordidas del caimán barbudo," in *Mea Cuba*, Mexico: Vuelta, 1993, p. 80.

The audience is heterogeneous, multiracial: intellectuals, workers, tourists, immigrants, sugar daddies, artists, beggars, pickpockets, crazies, hookers, gays.... Sometimes a gringo body-builder crosses the plaza, bored of dancing and drinking on Revolution Avenue, to immediately leave there because this place is gross.

Martín Romero, *Comicópolis*, Mexicali: Instituto de Cultura de Baja California, 1999, p. 61.

"WE ARE FROM TIJUANA, AND THERE IS A CULTURE CLASH IN TIJUANA;
THERE ARE PEOPLE FROM ALL OVER THE WORLD, AND ALL THESE
PEOPLE ARRIVE WITH A HISTORY. THESE PEOPLE APPROACH THE
GROUPS THAT SING CORRIDOS, AND TELL US MANY STORIES, SEND
US LETTERS, INCLUDING PEOPLE WHO ARE IN PRISON... THEN I
SEE THE MOST INTERESTING HISTORY. WHAT SHALL I SAY? WELL,
THIS HISTORY IS SIMILAR TO ANOTHER THAT IS INTERESTING, I CAN
MAKE ONE OUT OF SEVERAL DIFFERENT STORIES. SO I DEVELOP IT,
AND I ALSO PUT INTO IT 50% OF MY OWN THAT I BELIEVE WORKS
– BUT IT STILL IS REAL, AND THAT'S WHAT MOVES PEOPLE." "

Mario Quintero, composer and vocalist of Los Tucanes de Tijuana, in Elijah Wald, *Narcocorrido.*
Un viaje al mundo de la música de las drogas, armas y guerrilleros, New York: Harper Collins, 2001, p. 115.

"THE GANG CHASED HER
IN THE UNITED STATES
ALSO SENT THEIR PEOPLE
TO FIND HER IN TIJUANA
ONLY GOD CAN SAVE
CAMELIA THE TEXAN WOMAN." "

"Ya encontraron a Camelia," a corrido by Los Tigres del Norte

- 58% of the population in Tijuana older than 35 prefer ranchera, norteña, or tropical music. 49% of the youth between 18 and 24 and 38% of those between 25 and 34 prefer ballads in Spanish.

- Among those between 13 and 17, 33% prefer the ballad in Spanish, and another identical percentage like different music in English; 15% rock in English, and 12% ranchera, norteña, or tropical.

Mexican Institute of Radio–XHUN–Tijuana, 1986.

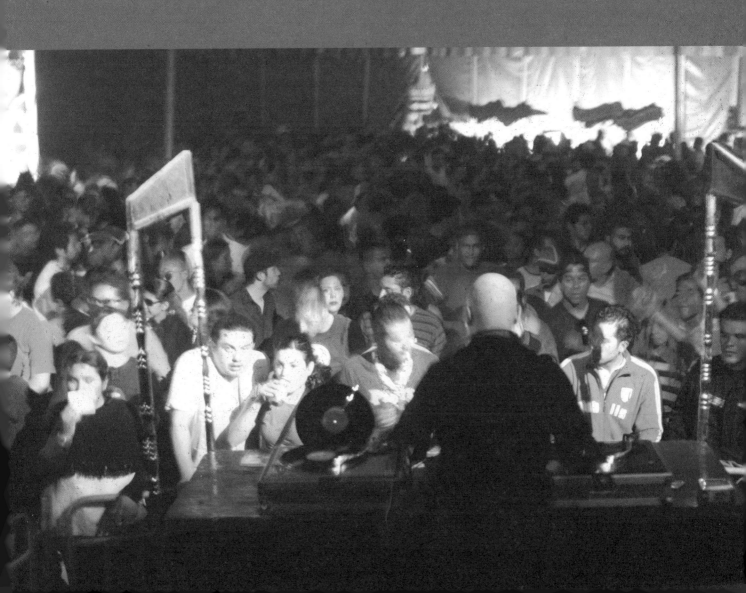

If we focus attention on the northern border, we see that radio has an importance in this region greater than in other parts of the country.

José Carlos Lozano, *Prensa, radiofusión e identidad cultural en la frontera norte*, Tijuana: El Colegio de la Frontera Norte, 1991, p. 36.

Nortec is a consequence of navigating between ideologies – American, Mexican, and European. The movement constitutes itself as a contestatory subculture that wants to subvert traditional musical codes by over-coding them.

Alejando L. Madrid, "Navegando ideologías entre culturas: prácticas de significación en la música Nortec," www.hist.puc.cl/historia/iaspm/mexico/articulos/Madrid.pdf

> **THE UNITED STATES GAVE US THE MUSIC, BUT TIJUANA GAVE US THE BIRTHPLACE WHERE MEXICO'S ROCK AND ROLL MUSICIANS BECAME GOOD. THE SCHOOL WAS HERE; THE UNIVERSITY WAS HERE.**

Javier Bátiz, in *Oye como va. Recuento del rock tijuanense*, eds. J. M. Valenzuela and Gloria González, Mexico: Conaculta Cecut/SEP/Instituto Mexicano de la Juventud, 1999, p. 70.

> **NORTEC IS THE SOUNDTRACK OF LIFE ON THE TIJUANA—SAN DIEGO BORDER.**

Terrestre (Nortec Collective).

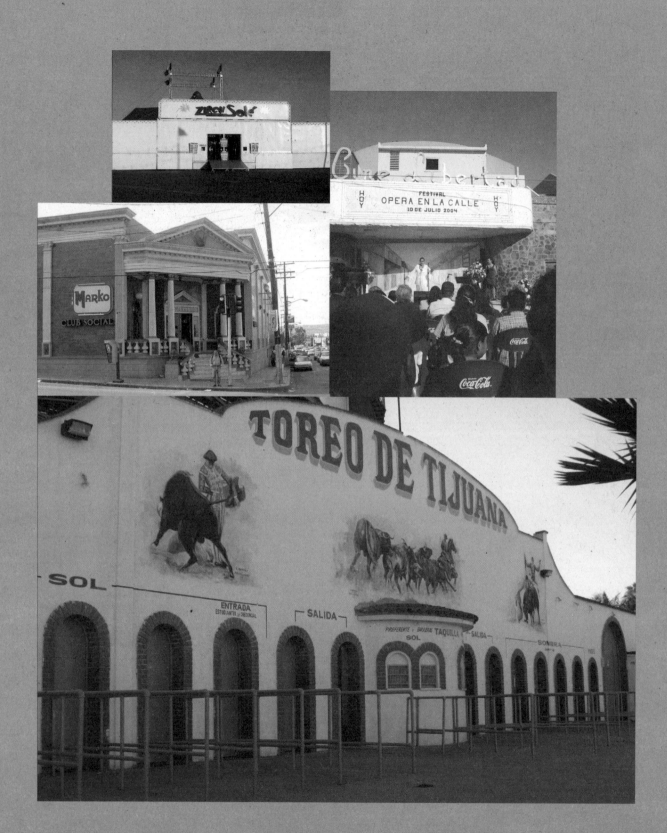

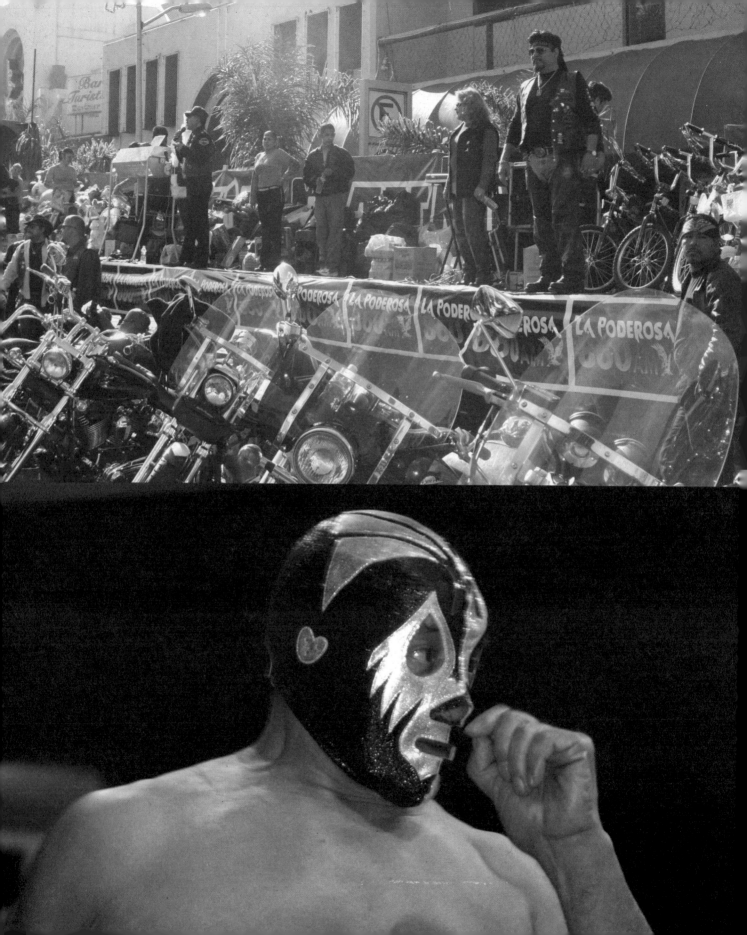

Fuerza Tijuanense

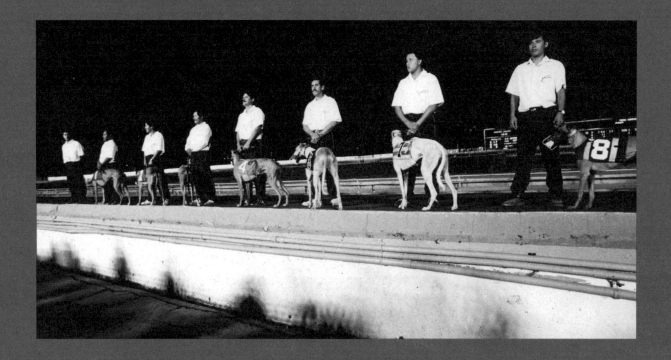

- In Tijuana there are 139,854 dogs, according to the Autonomous University of Baja California.

- Daily 80 to 100 animals arrive at the two plazas of the Central Municipal Antirabies Clinic.

- According to the Director of the College of Veterinarians in Tijuana, each Tijuanan dog defecates an average of 250 grams daily, which amounts to the totality of the dogs of the city producing 34 tons of excrement daily, according to *Zeta*.

www.zetatijuana.com

In a bid to shake off its negative image, the booming industrial city of 1.2 million
 people is attempting a bold make-over to replace its reputation for vice and
 criminality with a highbrow renown for the arts and culture.

 Tim Gaynor, Yahoo News.

Tijuana has become an essential stop on the reading and lecture circuit for
 intellectuals and writers from all of Latin America.

 Mark Weiss, "Introduction," in *Across the Line/Al otro lado. The Poetry of Baja California*, eds.
 Harry Polkinhorn and Mark Weiss, San Diego: Junction Press, 2002, p. 16.

No matter how much border patriotism is trumpeted, what's significant is the
 process where the economic connection with the United States becomes
 a life style, or even a musical atmosphere.

 Carlos Monsiváis, conference, Tijuana, 2001.

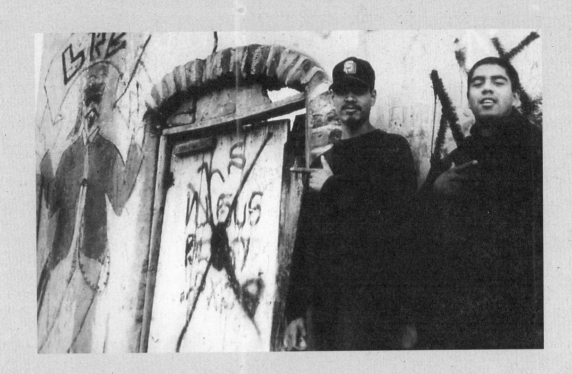

In the case of Tijuana, the cholos in great part are native youth of the city
(66.2%).... In contrast to the stereotype of the cholo as vagrant and
uninterested in work, we found that the majority of them (63.2%) were
working... they are workers, painters, carpenters, tilers, furniture
repairmen, employees in stores and service stations, upholsterers,
dishwashers, etc.. 72.8% of the cholo youth work or study.

José Manuel Valenzuela Arce, *A la brava ése: Identidades juveniles en México: cholos, punks y chavos
banda*, Tijuana: El Colegio de la Frontera Norte/Escuela Nacional de Trabajo Social, 1997, pp. 143–144.

The television channels in Tijuana are TV Azteca, Sintesis TV, Televisa (local network affiliates, 12 local, channel 45), Telemundo (channel 33), Cablemas. California channels (in English) are also received in the city.

The Tijuana Bloguita Front (TJBF) was opened in 2001. It functions as a network of hundreds of weblogs, where hundreds of electronic pages are mixed and 'linked.' These are of the type of adolescents, erotic, musical, photographic, local jokes, post-literary, and for organizing parties. According to Eduardo Andrade, 'the TJBF is the Tijuana of the Internet... high-brida, partysuda, recycling, self-made, whatttaaa!!!.'

www.rafadro.blogspot.com

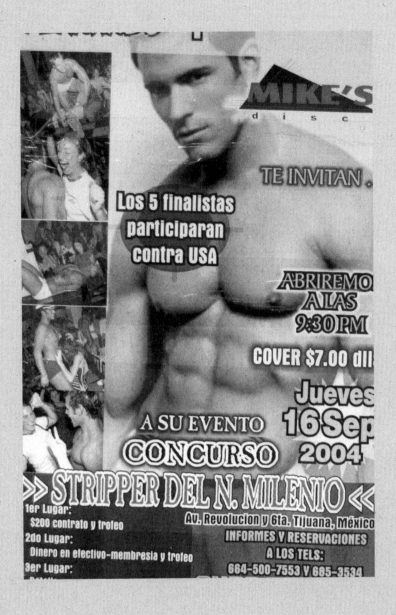

Extasis is a modern, clean gay dance club that is becoming very popular. It is 'the place' to party with Mexico's upper and middle class gays. The staff is friendly, the music is great and the strippers are HOT, HOT, HOT!!! Opens at 8 p.m. Thursday to Sunday. Lesbian Night on Thursdays. Cheap margaritas on Sunday.

www.angelfire.com/pop/guiagay/tijuanaq.html

▪ In Merida, Yucatán, more than 90% indicated they rented American movies; 66% expressed a preference for foreign films in the movies theaters, while only 6% liked domestic films. In Tijuana, two-thirds rented videos of North American movies; around one-tenth preferred domestic films as much on video as at the movies, and at movie theaters almost two-fifths preferred foreign films.

Enrique E. Sánchez Ruiz, www.mexicanadecomunicacion.com.mx/Tables/RMC/homer.htm

He asked the bartender what day it was and the bartender said,
'Thursday,' so he had a couple of days. They didn't run
until Saturday. Aleseo had to wait for the American crowds
to suck over the border for their two days of madness
after five days of hell. Tijuana took care of them. Tijuana
took care of their money for them. but the Americans
never knew how much the Mexicans hated them; the
American money stupefied them to fact, and they ran
through TJ like they owned it, and every woman was a
fuck and every cop was just some kind of character in
a comic strip. but the Americans had forgotten that they'd
won a few wars from Mexico, as American and Texans or
whatever the hell else. To the Americans, that was just
history in a book; to the Mexicans it was very real. It
didn't feel well to be an American in a Mexican bar on a
Thursday night. The Americans even ruined the bullfights;
the Americans ruined everything.

Charles Bukowski, "The Stupid Christs," 1967, in *Tales of Ordinary Madness*,
San Francisco: City Lights, 1983, p. 96.

The urbanization of international boundary areas presents a bold,
new research agenda for social scientists. The implications
for theories of urban space, politics, and planning represent
one area of inquiry that has gone relatively unexplored.
In the U.S.–Mexico case, the growth of border cities has
generated more than increased population density at
the boundary line, it has spawned a series of economic
and functional circulation patterns between 'twin' cities
that appear to eclipse the traditional screening functions
of boundaries.

L. Herzog, *Where North Meets South: Cities, Space, and Politics on the
U.S.–Mexico Border*, Austin: Center for Mexican American Studies, University
of Texas at Austin, 1990, p. xi.

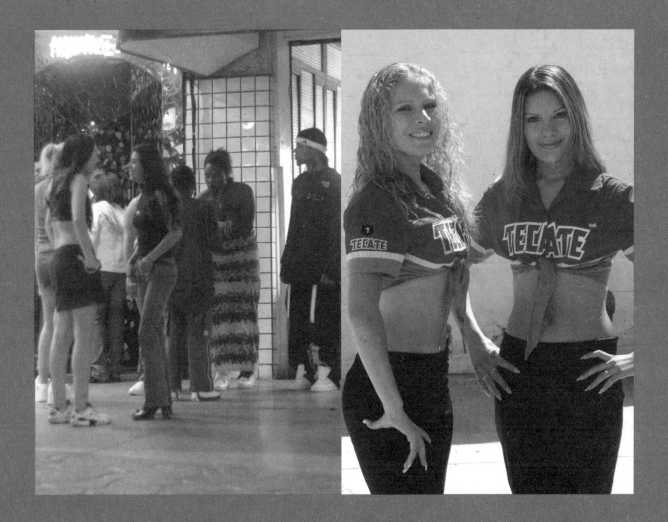

Most of the young U.S. partiers who go to the Tijuana bars spend little compared
to the adult restaurant and hotel clients who would visit Tijuana at night if
the streets were not dominated by the American youth drinking scene.
Lawmakers also have note of the fact that some of the Tijuana night club
owners live in San Diego and take their profit home to the U.S., making
the economic benefits to Tijuana negligible.

Border Policy Council/Consejo de Iniciativas Fronterizas,
www.alcoholdrugnewsroom.org/pdf_files/MA%2009.30.03%20v1-FINAL.pdf

The Arellano Felix brothers were born in Sinaloa. At the beginning of the 1980s they emigrated to Tijuana.

They began as small-time smugglers of cigarettes and alcohol. Now the Tijuana Cartel is the most powerful criminal organization in Mexico.

Thanks to their regional effectiveness, their violence, internal loyalty, the weakening of the Colombian cartels, their alliance with the authorities of both governments, and the overwhelming number of consumers, the Tijuana Cartel controls the majority of the traffic in marijuana, cocaine, and amphetamines along the border.

The Cartel has come to spend around $17,000,000 annually on gratuities and bribes in the Tijuana marketplace.

The known hierarchy of the Tijuana Cartel comprises a dozen persons, a Council of bosses who assume control of some 500 persons – according to the anti-narcotics authorities – including gunmen, money launderers, lawyers, drug distributors, and front men.

In addition there are 'junior narcs,' as the youth of the upper class are known who work as dealers or some form of intermediaries among drug dealers.

In 2000 the then general coordinator of the Cartel, or 'Godfather,' Jesús Labra Aviles, was captured as he was watching a game of American football at the stadium of the Lázaro Cárdenas preparatory school.

The Tijuana Cartel is said to own and use of a good number of restaurants, pharmacies, hotels, discos, all for laundering money.

From *La Jornada*, *Zeta*, *urban rumors*, and British Broadcasting Corporation, 2003.

According to José Alberto Márquez Esqueda, alias 'The Bat,' the Tijuana Cartel would pay him $80,000 to kill J. Jesús Blancornelas, editor of *Zeta*.

If accompanied, he would earn $250,000 to divide among his accomplices.

In 1997, David Corona Barrón, nicknamed 'Honorable Cowboy,' head gunman of the Arellano Félix brothers, made the attempt against the journalist, helped by 'The Bat' (a so called santero palo mayombe, witch doctor), and 'The Duck' (from Barrio Logan), as well as 'The Piwi,' 'Big John,' and 'The Wolf,' gang-bangers from Oceanside, and the Sinaloan killers 'M1' and 'M11.'

The majority were armed with AK47s (or Kaloshnikovs).

The plan died. Only Blancornelas' bodyguard died, and Blancornelas himself escaped wounded.

In 2004 a coeditor of *Zeta* was assassinated in his car with his two sons present.

www.zetatijuana.com

"AT NIGHT TIJUANA IS A CITY OF INDIGENTS. "

Andrés Mendez, Association of Mexican Curio Businessmen of Revolution Avenue and Adjacent Areas, www.frontera.info

- In 1993 for every 15 male users of toxic substances there was one woman; in 1998 it was down to 10 males for every female; and in 2004 it oscillated between six or seven male users for every female.

- According to the State Institute of the Woman, housewives use mainly synthetic drugs, some with the idea of losing weight and others to do more around the house.

- Increasing numbers of housewives consume methamphetamines, chiefly crystal, after having begun with some other narcotic, such as weight-loss pills.

- 40% of pregnant women who are seen in gynecology at the General Hospital have used them at some time.

www.frontera.info

- At the end of the twentieth century, there were around 50,000 hard-core drug addicts in Tijuana.

- It is figured that there are one or two hypes in each of the more than 750 neighborhoods. And there are about 1,000 gangs or, as they are commonly known, clicas ('posses').

- In 2000 and 2001 not a single person was registered in relation to police searches of the hundreds of 'little stores' that operate in the city that has the highest national average consumption of drugs.

- In 2003, 473 'little stores' were closed. More than 80% were located in houses and were operated by entire families.

From *El mexicano* and Seguridad Pública de Tijuana, 2004, www.el-mexicano.com.mx

They say that there is an aphrodisiac called 'Spanish fly,' and one or two drops are enough to put someone in a state of frantic uncontrollable sexual desire. No one I know has seen a Spanish fly but only a friend of a friend (ah, sure, I forgot to say that the source of all rumor is the friend of a friend of a friend...). But Spanish fly, it is said, can be bought in Tijuana. Everything can be bought in Tijuana. Everything can be sold in Tijuana. This, for sure, is another rumor...

Lewis Baltz, "Urban Rumors, A Project Curated by Hans Ulrich Obrist. Produced in Collaboration with Fri-Art," in Rem Koolhaas, *Mutations*, Barcelona: Actar, 2001, p. 727.

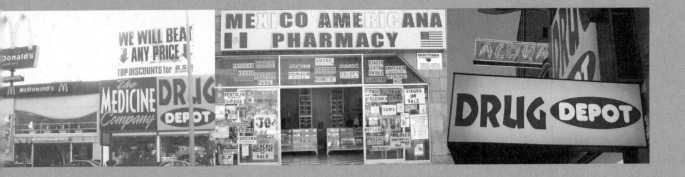

■ The Méxican border city is not only the area where the most televisions on the planet are produced, nor that which for years claimed the honor of being the place with the most cantinas in México: 550. Now it is also known as that of the biggest drug stores and clinics in the world. Its 1,400 drug stores contrast with the hundred or so drug stores in San Diego.... For every bar or night club on Revo there are two or three drug stores.

Gisela Vázquez, "La farmacia más grande del mundo," *Expansión*, June–July, 2003

■ Annual amount of sales of medicines in Tijuana: $100,000,000.

■ The adult tourist population spends an average of $300 on medicines in Tijuana. The visiting population – between 16 and 20 years of age – between $15 and $20.

■ It is estimated up to 70% of those medicines are sold without any prescription.

■ 7,000 employees work in 1,400 pharmacies.

Gisela Vázquez, "La farmacia más grande del mundo" *Expansión*, June–July, 2003.

"TIJUANA IS THE HAPPIEST PLACE ON EARTH. "

Krusty The Clown, *The Simpsons*

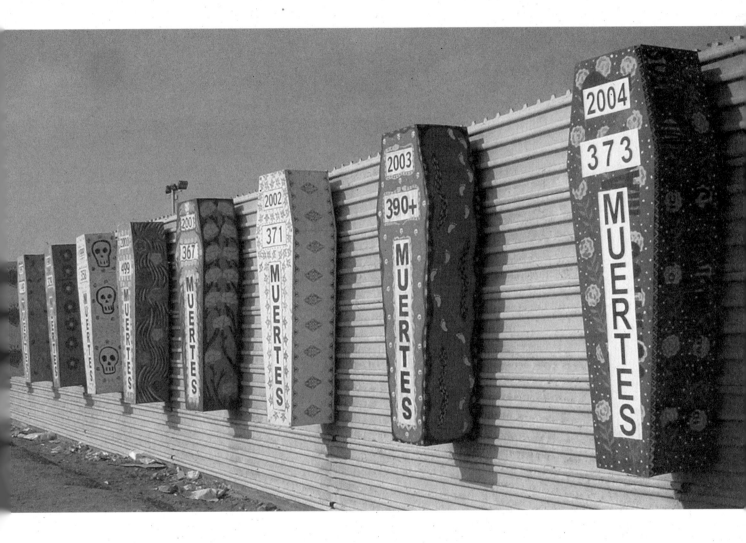

CHAPTER 3
PERMUTATIONS

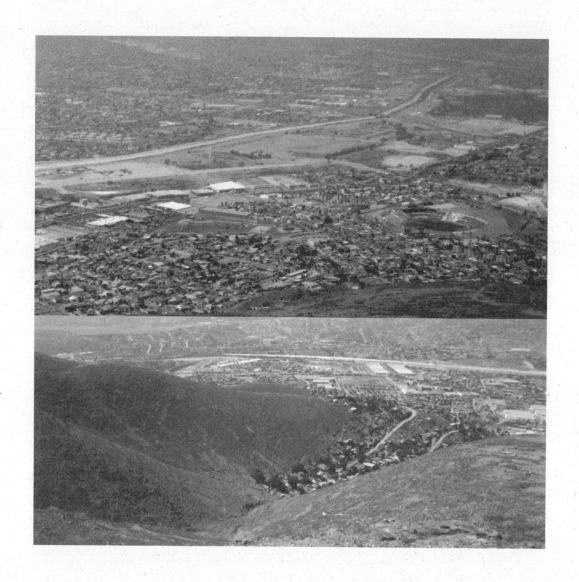

NEW TIJUANA

The Eastern part of the city begins to be known as the Nueva Tijuana, 'New Tijuana.' The area is made up of neighborhoods like Mariano Matamoros, Valle Verde, El Florido, Fraccionamiento El Niño, Ejido Maclovio Rojas, Lomas del Valle, and many others. Between 700,000 and 1,000,000 people live here. The area was formed, in large part, through squatting. This is where the majority of migrants end up settling down.

Rent of commercial locales is usually higher than in the city center. It is in New Tijuana that the most significant public works of recent administrations have been realized. Owing to this development, and its distance — in certain cases arriving to downtown Tijuana can take more than an hour and a half by public transportation — the area has become self-sufficient, and some residents — as sometimes happens with Tijuanans who live in Playas — refer to 'Tijuana' as if it were another city.

'Officially 304,737 people live in La Presa, according to INEGI data, but according to municipal calculations the number is double that, and the area is home to a third of Tijuana's population,' according to the weekly *Zeta*.

The data of traditional Tijuana and New Tijuana are very different. If the INEGI data establish that 95% of the city's homes have solid floors or cement floors, in New Tijuana it is figured that one of every four people lives in a home with a dirt floor.

The percentage of the population that works is from 10 to 15% higher than the rest of the city.

At the least, 50% of the residents of East Tijuana live in conditions of overcrowding, and as many as 80% lack sewage services and/or running water.

The majority of these residents work in assembly plants and other industries (18%).

While 13% are laborers or helpers, 16% work in business, and 14% are professionals. 12% work in administrative areas, the rest in other kinds of services.

New Tijuana is considered unsafe. The majority of rapes, kidnappings, and home robberies happen there. Of course, New Tijuana has its own night life.

To the question of why so few inhabitants of traditional Tijuana are aware of the development of a semi-parallel Tijuana, Ramón, a grocery store worker in Mariano Matamoros, says, "What happens is that they go on thinking that Tijuana is there." Félix, a resident of the Playas area of Tijuana, told us, "In those neighborhoods is where the maquilarañas live."

'Maquila-arañas' (lit. assembly-plant 'spider' girls) is a pejorative term that some Tijuanans use for poor female employees of the assembly plants.

With regard to New Tijuana — a kind of Post-Tijuana — popular definitions are beginning to emerge. Some call it the Tijuana behind Colorado Hill (Cerro Colorado).

"Have you seen all these pale washed-out areas that do not look like Tijuana, when the airplane is getting ready to land? Have you noticed that passengers wonder if what they're seeing is already Tijuana?" Leticia makes the face of someone who appears in an airplane window not knowing what she sees below. "Ah, well, all of that which people don't recognize from up there, that's here."

Leticia lives in the Casa Blanca neighborhood, a part of New Tijuana. Also, she says, there is nothing like driving full speed along Gato Bronco Boulevard.

New Tijuana grows two hectares daily.

From *Zeta*, and neighbors of the "New Tijuana," 2004.

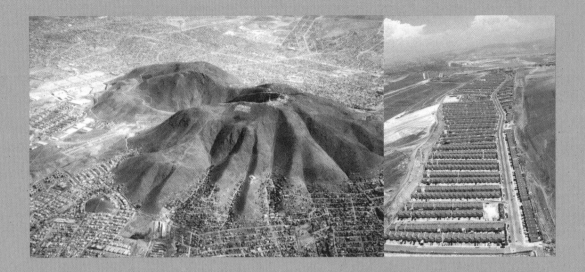

The city of Tijuana occupies an area that was originally inhabited by the Kumeyaay people. The first European explorer of this area was Juan Rodríguez Cabrillo in the year 1542.

David Piñera, *Tijuana en la historia. Una expresión fronteriza de mexicanidad*, Tijuana: Ediciones ILCSA, 2003.

According to the Plan of Urban Development, the city has an annual population growth of 6%. Since 1984 Tijuana has been building on lands that were set aside for ecological conservation.

Rosalbina Pérez Cerón, Office for Civil Protection, El Colef.

"TIJUANA GROWS BY THE SIZE OF A ROSARITO ANNUALLY."

Gerardo Ordóñez Barba, El Colef.

According to figures of the National Home Ownership Chamber, at the beginning of the twenty-first century Tijuana had a shortage of 60,000 houses. 17,000 houses are constructed annually.

The United Nations recommends that affordable dwellings should have at least 15 square meters per inhabitant.

On average, builders erect structures of fewer than 30 square meters. The units cost between 150,000 and 180,000 pesos. They will be inhabited by families of four or more members.

"With regard to what is called a dwelling, builders in Tijuana sell 'dream houses' which, in general, turn into a debt for the buyer, because the developer doesn't comply with what is offered or rather because the product is of poor quality," according to the weekly *Zeta*.

To the question put to Carmen and Max Gonzalez as to why exactly they had gone to Morales Park, they answered, "To take a break from our house."

Interviews and www.zetatijuana.com. 2004.

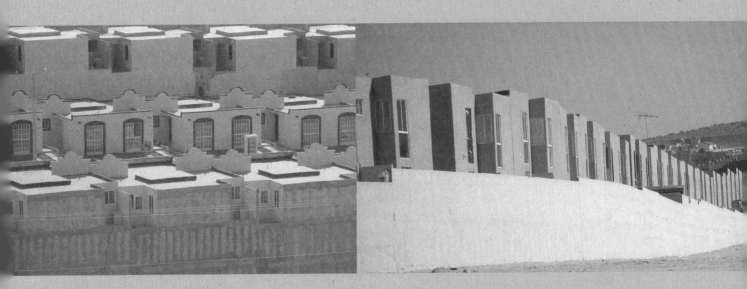

- In 1950 65,364 inhabitants lived in Tijuana on 1668 hectares.

- In 1960, 165,690 residents on 4,285 hectares.

- In 1970, 340,583 residents on 6,891 hectares.

- In 1980, 461,257 residents on 11,957 hectares.

- In 1990, 717,058 residents on 16,262 hectares.

- In 2000, 1,212,232 residents on 86,788 hectares.

XII Censo General de Población y Vivienda, INEGI, 2000.

The reduction of living space from 72 to 27 square meters in popular housing causes physical and psychological changes in their occupants, among them violence, specialists have assured. The general director of the State Mental Health Center, María Consuelo Herrera Pérez, asserted that crowding is a risk factor that foregrounds tension.... 'We just have no privacy as a couple, and my five-year-old son (Christian Bermúdez) already wants his own space, but where? He stays in the bedroom playing by himself, but we are always all there,' says Melina Esquivel Segura, who lives with her husband and two sons of two and five years.

www.frontera.info

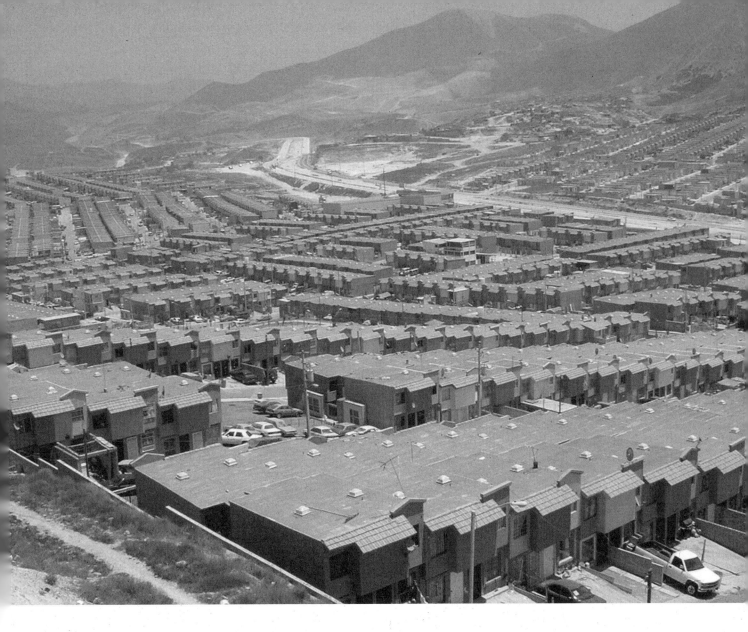

▪ Tijuana has a surface of 123,584.08 hectares, once we subtract
the 51,332 hectares that were taken from it to create, in 1994, the
municipality of Playas de Rosarito.... In relation to the surface of
the state of Baja California, Tijuana represents only its 1.53%.

David Piñera, *Tijuana en la historia. Una expresión fronteriza de mexicanidad,* Tijuana: Ediciones ILCSA, 2003, p. 15.

In 2000, Baja California had 610,057 dwellings, with an average of four occupants per unit. 75.5% are free-standing dwellings, which don't share walls, ceilings, or floors with other homes. 6.2% are apartments in buildings; 5.1% share bathrooms and water service as well as walls, floors, and ceilings.

Programa de Desarrollo Urbano del Centro de Población de Tijuana, B.C. 2002–2025, Instituto Municipal de Población, Tijuana, 2003.

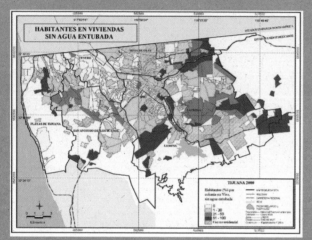

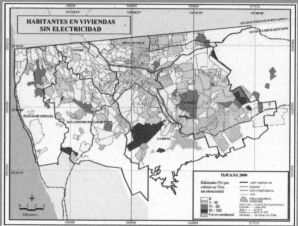

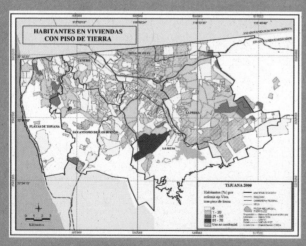

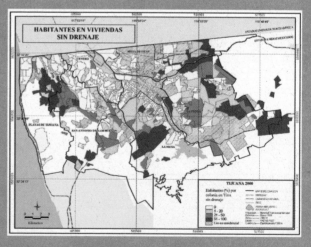

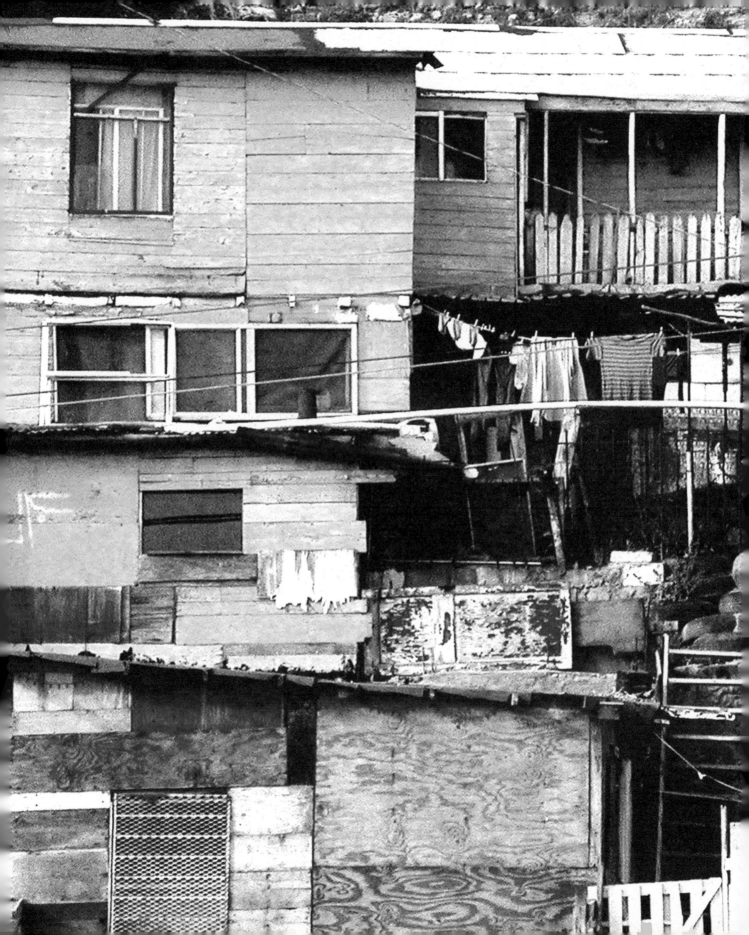

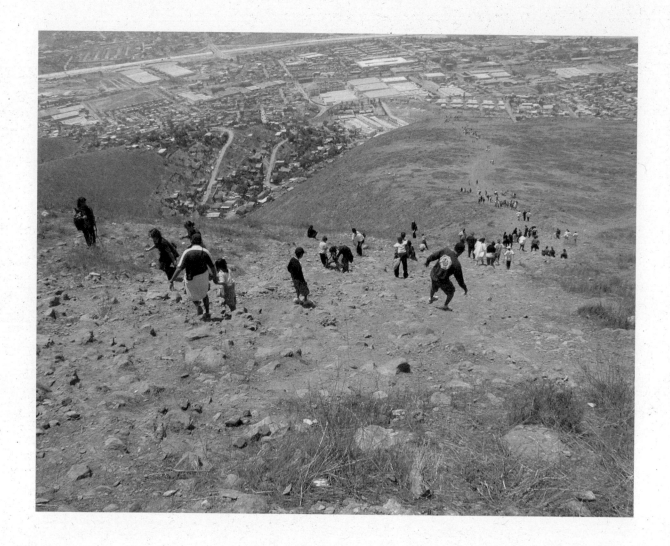

In no place have I felt, as in Tijuana, the force that a territory imposes on its inhabitants. The city has a vocation of belonging to all and in it one can breathe a strange pride, maybe the pride of being a gigantic hotel without doors. Not being imagined as a real city, but as part of a strategy, not as end but as means, ruined that aura of 'being for always' that the majority of cities have. There is the sense that at any moment everyone will go and will move to the middle of the desert or to another border.

Guillermo Fadanelli, www.fadanelli.blogspot.com

- The official introduction of maquiladoras in Mexican territory began through the Border Industrialization Program in 1965.

- 96.5% of the Manufacturing Enterprises of Baja California, according to data of INEGI (1995) are PYME (Small and Medium Size Businesses), that is, those that have 250 or fewer employees. 2,205 of such businesses are located in Tijuana.

- 99.99% of the commercial establishments in Baja California are PYME. In 1993, these establishments employed 83,978 persons. 11,848 of these businesses are located in Tijuana.

- 99.4% of the services sector of Baja California is PYME. In 1993, this sector employed 80,387 persons. 9,855 of these businesses are located in Tijuana.

- In a survey of the Secretary of Economic Development of the State (1995), 92% of those surveyed responded they didn't know about programs of financial support for small and medium businesses.

Ocegueda, El Colef.

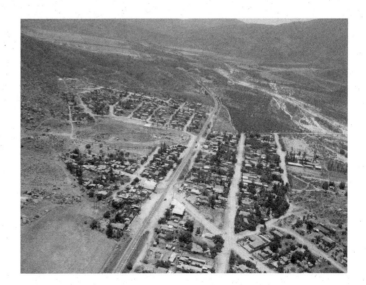

" TIJUANA IS IN THE MIDDLE OF AN ARTISTIC FLOWERING THAT HAS DRAWN ATTENTION FROM TELEVISION EXECUTIVES AND MUSEUM CURATORS FROM NEW YORK TO TOKYO. ARTISTS OF ALL STRIPES ARE RE-EXAMINING THE HYBRID CULTURE OF TIJUANA THAT EXISTS BETWEEN THE GLITZ OF SAN DIEGO AND THE FACTORY LIFE DIEGO RIVERA COULD HAVE PAINTED. "

"The New Cultural Meccas of the World," *Newsweek*, Atlantic Edition, September 2002, p. 56.

- The border between Mexico and the United States is 3,000 kilometers long and is the most asymmetrical border in the world.

- A trait of this border are the twin cities, such as El Paso/Ciudad Juarez and San Diego/Tijuana. The North American twin is the richest, the Mexican the biggest.

Televisa.

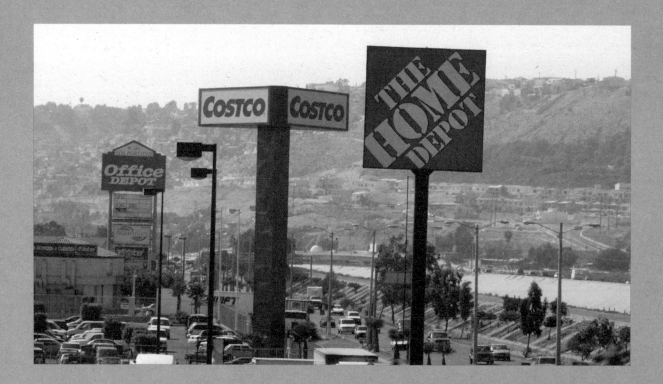

According to the Municipal Planning Institute, Tijuana will have 2,574,284 inhabitants in 2020. When we asked Pablo, a torta vendor in the Sánchez Taboada neighborhood, what he thought of this fact, he said that this prediction had come true. 'In 2003.'

Interviews 2004 and IMPLAN.

The city generates 1,500 tons of non-solid non-dangerous waste daily, which end up, according to the State General Office of Ecology, in 64 dumps.

The Tijuana River is one of the 31 most contaminated aquifers in the country. According to data of the Gaviotas Ecological Group, almost 40% of the population's waste water is not processed by the sanitary system, nor does it receive adequate treatment.

Gobierno del Estado, Baja California and the Ecologist Group Gaviotas.

ASSEMBLYLAND Total of Mexicans working in the assembly plant industry: 1,550,383.

Employees who are men: 539,335.

Employees who are women: 516,048.

Employees who are workers: 83,954.

Employees who are technicians: 136,443.

Administrative employees: 84,986.

Workers who are men: 384,618.

Workers who are women: 449,336.

Male technicians: 100,231.

Female technicians: 36,212.

Male administrative employees: 54,486.

Female administrative employees: 30,500.

Total workers in the border states: 820,870 (78%).

Employees in Baja California: 212,125 (20%).

Total assembly plants in Mexico: 2,838.

Assembly plants located in border states: 2,060.

In Baja California: 878 (31% of the national total).

Maximum number of assembly plants reached in the country: 3,763 (June, 2001).

Mexican city with the most assembly plants: Tijuana, with 562.

Maximum number reached in Tijuana: 820 (February, 2001).

Assembly plants closed in Tijuana in 2004: 258.

Mexican city with the most assembly plant employees: Ciudad Juarez, with 196,979.

Cities that have gained assembly plant employees from October, 2000, to the 2004: Reynosa (5,856) and Ciudad Acuña (2,266).

Personnel turnover before the industrial crisis: 11–14% monthly.

Turnover through the closing of hundreds of assembly plants: 2%.

Growth of the work force in assembly plants since NAFTA went into force (January 1, 1994) until December, 2003: 508,795.

Place occupied by Mexico among world exporters: 11.

Dollars from each 100 that have their origin in the assembly plant industry: 54.

Percentage of domestic raw materials that the assembly plant industry employs: 2%.

Cost of Mexican components that are added to a television valued at $243: $4.75.

Percentage of minimum support that is covered by real salaries of the assembly plant workers: 25%.

Cost in dollars of a gallon of milk on the Mexican border: $3.27.

Cost of the gallon of milk in New York: $2.57.

Increase of salaries paid to workers: 1.0%.

Percentage decrease of the real salary of workers in 2003: 2.1%.

Money that the Mexican workers receive from selling their blood to American blood banks in order to complete their expense: $15.

La Jornada, Comité Fronterizo de Obrer@s, INEGI, 2004.

All the women had assimilated the fundamental words of being an industrial worker: enter, leave, push, pull, hurry, pull the handle, 'push' the button, produce, no smoking, no talking, no resting; and yet they didn't forget the 'magical' words of being woman: cook, sweep, iron, look after their children, don't sit, educate yourself, make love, get out, shut up, buy. For all of this, talking made sense.

Norma Iglesias, *La flor más bella de la maquiladora*, Mexico: Secretaría de Educación Pública y Centro de Estudios Fronterizos del Norte de México, 1985, p. 25.

We are witness to a socially worrisome problem in Tijuana: a city that can boast to the rest of the country of its accomplishments in economic growth has not been able to counteract the growth of inhabitants with economic and social shortcomings. Owing to the surfeit of employment, the workers can go from one job to another relatively easily.... The workers present a high index of mobility. And this mobility has gather them in jobs where human capital, seen as the trajectory of the accumulation of knowledge and capacity, has little influence on the wages they receive and the jobs they hold.

Humberto Palomares León, "Entre la pobreza urbana y el crecimiento económico," *Problema del desarrollo*, vol. 19, no. 112, 1998, p. 45.

- **The service, business, and manufacturing sectors are the principal areas in which Tijuanan women work.**

- **In 1995, 57.2% of the total of employees of the assembly plant industry of the border states were women.**

Martínez Canizalez, El Colef / INEGI.

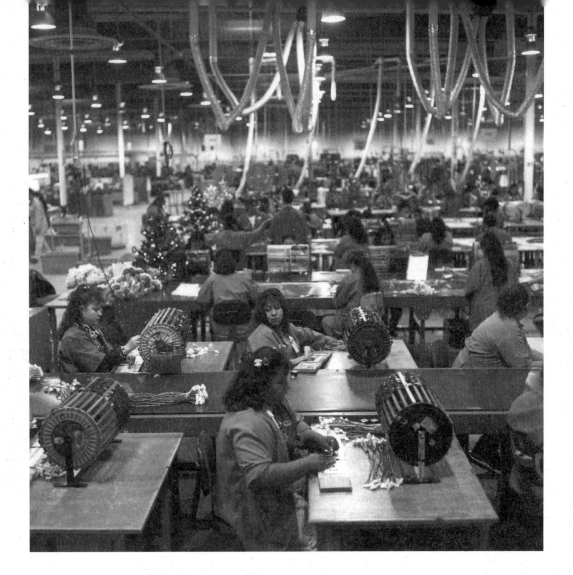

- 64% of the assembly plant women workers are sexually active and have on average 2 children. The average age is 29.4 years.

- 67% of them are in relationships (married or consensual).

- 21.7% are separated or widowed.

- 11.3% are single.

- The mean age when they enter relationships is 18.6 years.

- Two of 10 of these women have had an abortion.

Georgina Martínez Canizales, "Predictores del Papanicolau en las obreras de la industria maquiladora en Tijuana, B.C.," Postgraduate thesis on demographics in El Colef, p. 63–64.

- IN **1992** THE COST OF ASSEMBLY IN THE UNITED STATES WAS **$90;** IN TIJUANA, **$15.**

- SINCE **1989** MEXICO HAS BEEN THE FIRST EXPORTER OF COLOR TELEVISIONS TO THE UNITED STATES.

- IN **1996** THE FIVE TELEVISION SET COMPANIES LOCATED IN TIJUANA ABSORBED **16%** OF THE EMPLOYMENT IN THEIR AREA AND **12%** OF THAT GENERATED BY THE LOCAL MAQUILADORA INDUSTRY.

Ismael Aguilar Benítez, Estudios Sociológicos.

On the northern border, faced with the structural weakness of institutions and relations of traditional production, next to a reduced population with low demographic dynamism, modern capitalist economic relations could be expanded and developed in an unusual way, without further restrictions than those that could be placed by natural and peculiar geographic conditions of the region.... Economic development and demographic growth of the border cities are sustained in the process of industrialization initiated in the middle of the 1960s with the locating of assembly plant export industries. In this way, between 1970 and 1990, the industrial BIP in this region grew 3.6 times, contrasting with the moderate growth that the metropolitan areas registered, especially Mexico City and Guadalajara.

Alejandro I. Canales, "Culturas demográficas y poblamientos modernos. Perspectivas desde la frontera México-Estados Unidos," in *Por las fronteras del Norte. Una aproximación cultural a la frontera México-Estados Unidos*, ed. José Manuel Valenzuela Arce, México: Conaculta, 2001, p. 114.

Assembly plants are those manufacturing plants established in Mexico: a) that are affiliated with contracted U.S. businesses or plants, whether capitalized within Mexico or abroad; b) that are dedicated to the assembly of components and/or processing of raw materials, whether of intermediate or final products; c) for which almost all of raw materials and/or components are imported from the United States and re-exported anew to this country, once the assembly process is completed; and d) that use intensive labor.

Norma Iglesias, *La flor más bella de la maquiladora*, México: Secretaría de Educación Pública y Centro de Estudios Fronterizos del Norte de México, 1985, p. 21.

■ Tijuana is the border city with the most assembly plants. Between
1996 and 1998 571 plants were in operation, which employed about
100,000 persons.

Municipal Development Plan, 1996–1998, Tijuana: Instituto Municipal de Planeación.

■ It is figured that 70% of the assembly plants that leave México are
set up in China.

Channel 33.

From the 1960s to the beginning of the 21st century the largest graveyard of used tires in Mexico has been accumulating. According to the Secretary of the Environment and Natural Resources, it has grown to more than 4,000,000 tires.

In 2004, the Secretary came to an agreement with others to get rid of this graveyard and other dump sites as the property of the Metals and Derivatives business, which kept 6,000 tons of slag lead illegally abandoned by the New Frontier Trading Corporation.

www.jornada.unam.mx

■ TO REPAIR A TIRE IN A TIRE SHOP COSTS BETWEEN 25 AND 50 PESOS; TO PAY THE TIRE MAN TO DISPOSE OF AN OLD TIRE, 15 PESOS.

Interview, 2003.

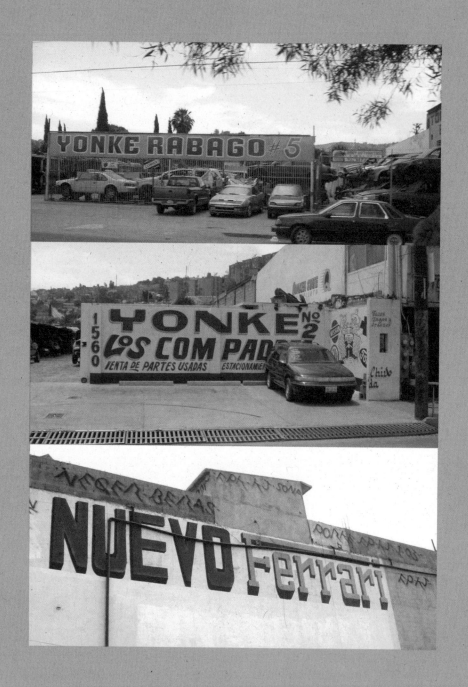

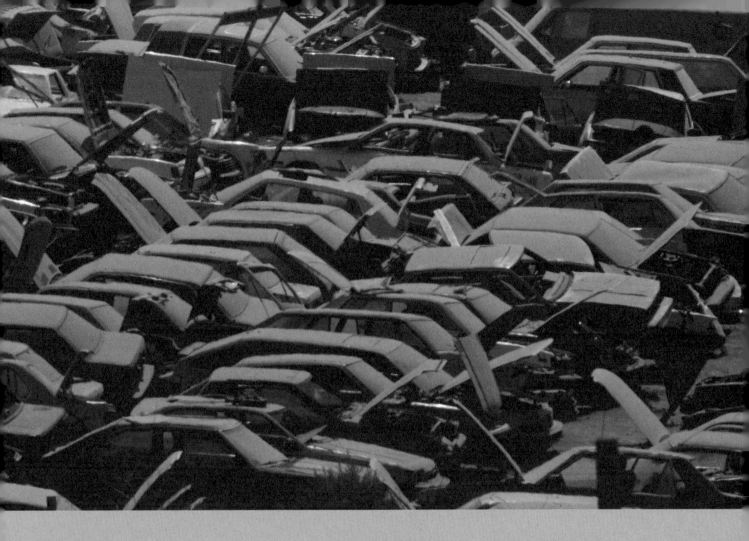

■ IN **2004,** THE CITY GOVERNMENT HAD **928** REGISTERED
AUTOMOBILE REPAIR SHOPS.

www.frontera.info

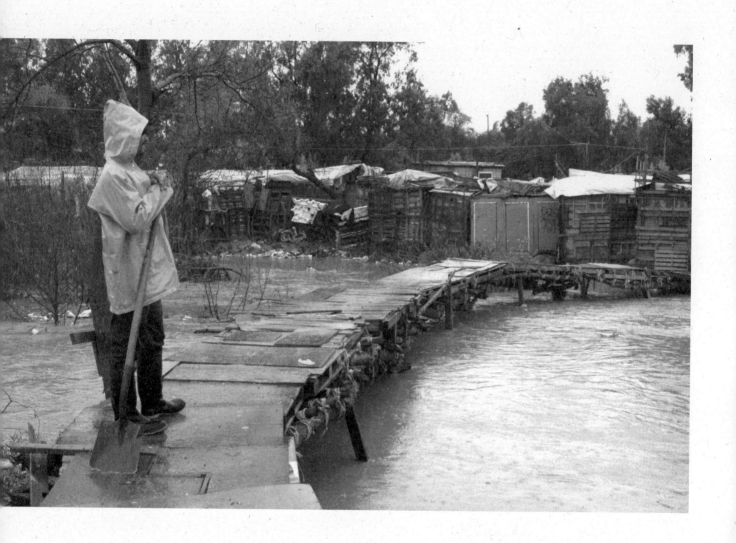

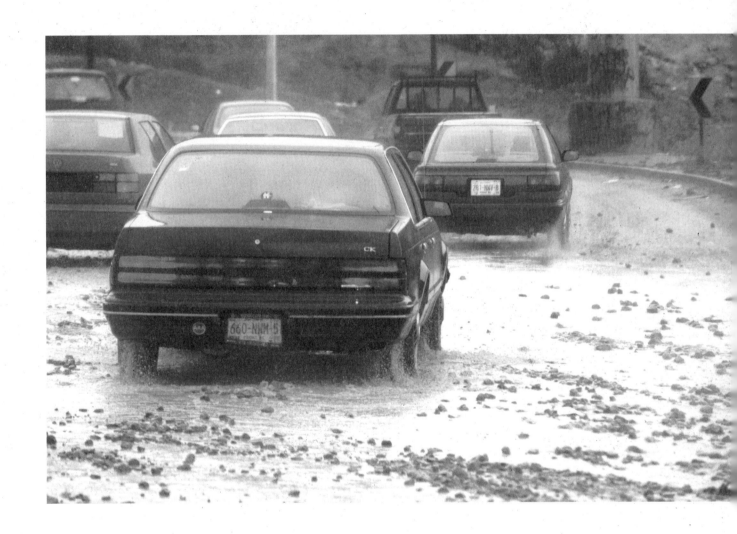

According to the Office of Civil Municipal Protection, one fourth of Tijuana's citizens would suffer from the devastation of sporadic, intense rains, from being stranded in cars, homes, to the destruction of their homes, walls collapsing or, in the worst of cases, the loss of lives.

www.frontera.info

According to the legislator Jaime Martínez
 Veloz in the 2001 campaign for municipal
 presidency, the owners of bars and
 cantinas in the Northern Zone cooperated
 with $10,000 each for the campaign of
 the candidate of the National Action Party.

Martínez Veloz calculates that there are
 100 establishments of this kind in the
 Northern Zone.

www.jornada.unam.mx

On March 23, 1994, Luis Donaldo Colosio, PRI candidate for the presidency, is campaigning in Tijuana. He attends a meeting in Lomas Taurinas, a marginal area. Hardly three months ago the Zapatista rebellion in Chiapas erupted. The country is tense.

Mario Aburto, a maquila worker from Michoacan who believes himself to be an Aztec 'Eagle Warrior,' draws near to Colosio and shoots him. Aburto is detained, and Colosio dies shortly afterwards.

Interrogator: How long have you been here in Tijuana?
Aburto: Almost eight years.
Interrogator: Why did you come here?
Aburto: Because I wanted to begin everything from here, from Tijuana.
Interrogator: Begin what?
Aburto: To begin working on the project.
Interrogator: What project?
Aburto: A project I can't talk about.

Héctor Aguilar Camín, *La tragedia de Colosio*, México: Alfaguara, 2004, pp. 172–173.

"TIJUANA A.C. (TIJUANA AFTER COLOSIO)."

Edmundo Lizardi, "Encuentros fronterizos: De La Paz 84 a Tijuana 97," *Bitácora*, May 9, 1997.

In 1988, the journalist Héctor 'The Cat' Félix Miranda of the weekly *Zeta*, known for his black
humor turned against regional politicians, was assassinated by two men who worked for the
owner of the Agua Caliente Racetrack and elected as municipal president in 2004, the year
that another coeditor of *Zeta* was executed.

www.zetatijuana.com

The most notorious prison of Tijuana is the State Penitentiary. This pen has been popularly known as 'La Peni' or 'The Little Town,' since inside there are restaurants, buffets, grocery stores, liquor stores, and bars. The pen is celebrated for its influence in trafficking and purchasing of privileges, escapes, and moreover because for a long time the offenders' families lived inside.

In 2002, the State government moved 2,255 prisoners to another center, known as 'The Mushroom,' in Tecate. In this operation there were also 300 women and children who were ousted.

That year the surplus population was greater than 4,000 prisoners, since this institution was constructed to house only between 2,000 and 2,500 prisoners.

According to penal authorities, 70% of prisoners are drug addicts.

According to the Federal Secretary of Public Safety, inside 'La Peni' various illegal activities are carried on, such as trafficking in all kinds of drugs — administered by the Tijuana Cartel, according to what is said — money counterfeiting and conducting criminal activities outside the prison, which represented transactions of as much as a million dollars a day. According to the weekly *Zeta*, in this period $100,000 was turned each month over to prison authorities as bribes.

In 2001, the Mexican Commission on Human Rights declared this jail 'the worst in the country' owing to crowding, criminality on the inside, corruption of its charges, and the general distribution of privileges.

www.frontera.info and www.zetatijuana.com

The first times that I went to celebrate Mass in 'The Eight' (the Tijuana jail, located in downtown Tijuana) I was very disgusted – not only by the ugliness and misery I found in this place, but above all by the barrier of the bars. I have worked in various jails and penitentiaries in the United States, but never have I felt such a deep resentment and disgust as I experienced in the Tijuana jail with its old, ugly bars, which represent for me the chains of oppression – especially the kind of barriers that migrants encounter. I say 'migrant' because the majority of the detainees are from other parts of Mexico. According to what the detainees told me, whoever has spent more than three years in The Eight – now more than 70% of the prisoners – is not from Tijuana.

Gilbert J. Gentile, "Barreras y puentes. (Experiencia en la cárcel de la Ocho)," *El Bordo*, no. 2, pp. 71–72.

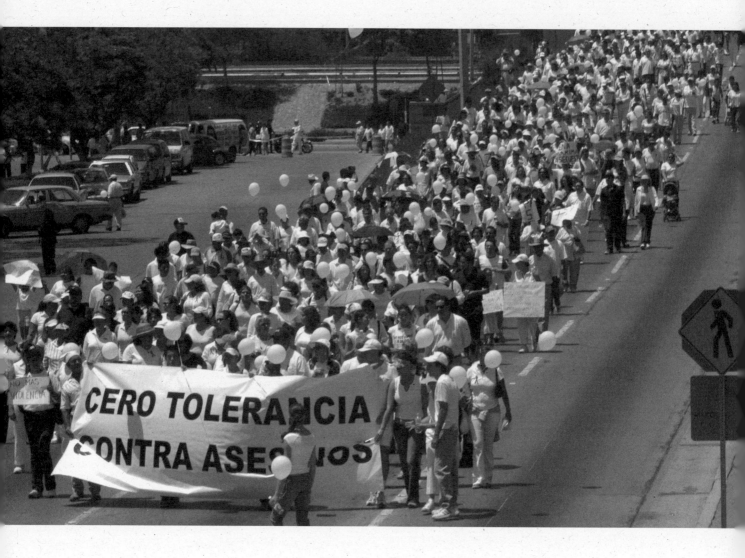

In the month of October, 2003, the police of the Secretary of Municipal Public Safety reported having dealt with 24 incidents in the Libertad neighborhood (in the area of the Mesa de Otay); 25 in La Mesa (La Mesa); and 57 in Mariano Matamoros (La Presa).

In all of 2003 there were 193,144 persons referred to the Public Ministries.

www.frontera.info

" **ALWAYS THE SAME COMPLAINT: THE TIJUANA POLICE BEHAVE BADLY.** "

Oscar Genel, *Tijuana. Ciudad de contrastes*, Tijuana: Ediciones ILCSA, 2000, p. 136.

■ After finishing their work day, 150 policemen have to turn in their pistols so that another 150 policeman can use them. In Tijuana there are 1,534 police officers and 900 pistols for their use. The Municipal Police of Tijuana promise that in the future not only will each one be able to count on having his own pistol but also each one will drive his own police car.

Frontera, Public Municipal Safety.

■ In 2004, seven different police agencies existed in Tijuana.

www.zetatijuana.com

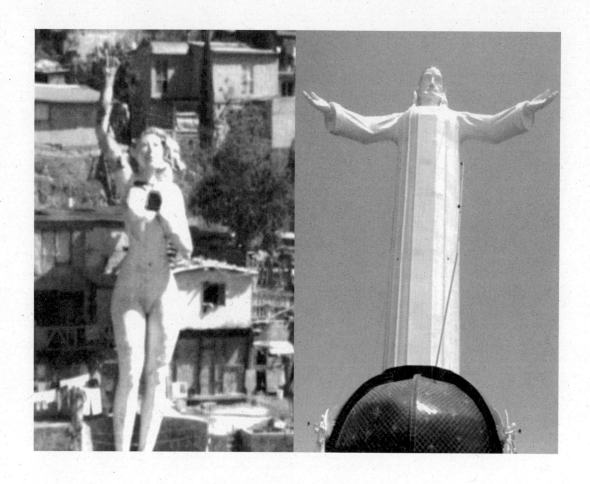

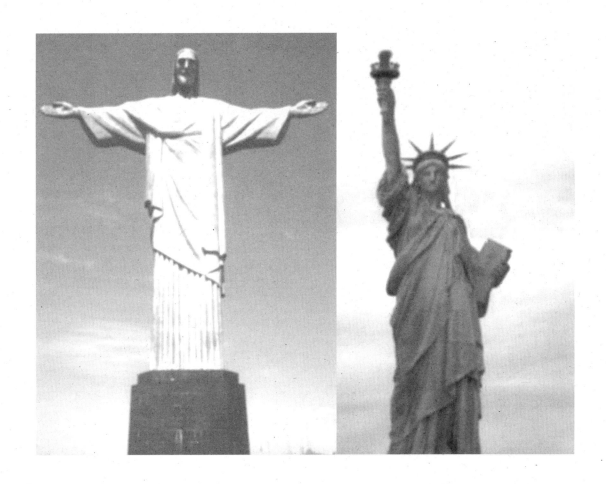

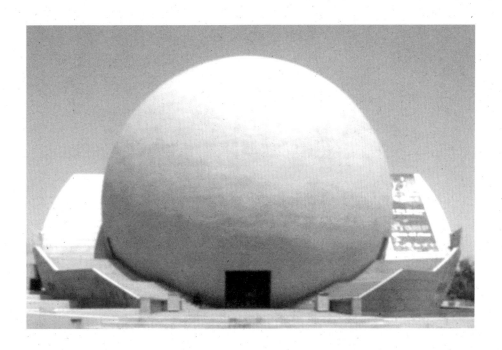

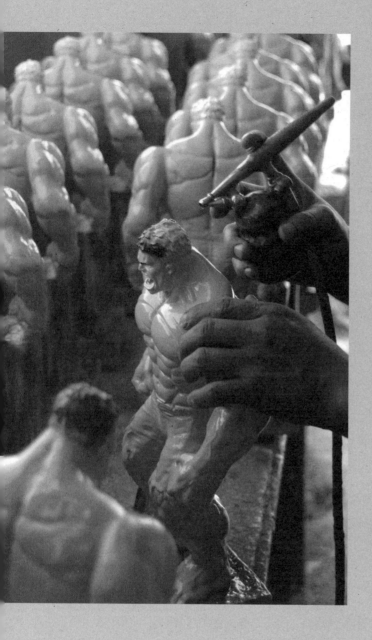

"AT THE CROSSING GATES IN TIJUANA CARS STOP TO BUY EVEN MORE SURPRISING CURIOS. WE ARE AT THE ONLY PLACE IN THE WEST WHERE A PLASTER BART SIMPSON OF THE SIZE OF A SERVIBAR IS CONSIDERED DECORATIVE.... THE CURIO-MAKERS FOLLOW HOLLYWOOD RELEASES."

Juan Villoro, "Nada que declarar. Welcome to Tijuana," *Letras Libres*, no. 17, 2000, p. 17.

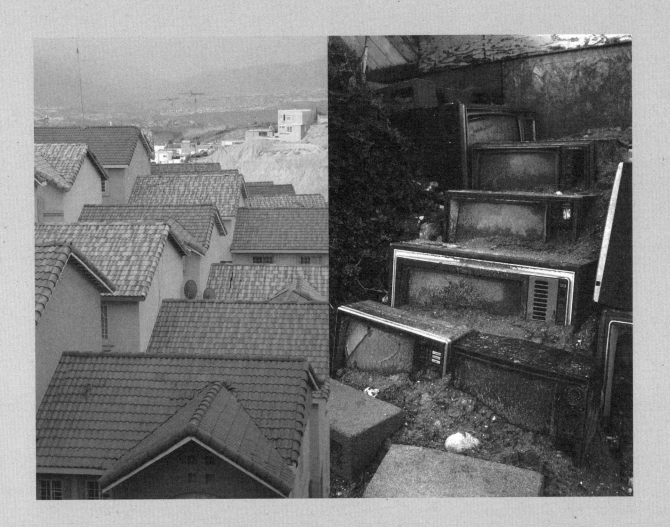

The zone that encircles Guerrero Park is the prototype of what remains of old Tijuana. In the 1950s to live in the Cacho neighborhood was a sign of status; then the race track appeared, and Chapultepec, and then there will be a Playas of Tijuana decade, the ocean face of the city that is the 'other Tijuana' (because they say that there are many Tijuanas). Both chalets and numerous villas appear in the urban scene, of course, of the most hybrid and aberrant kind. We find all kinds of designs: the house of Wood 'brought from the other side,' that of more modest materials made like God gave them to understand, 'the commercial city or government-sponsored housing; a crown of an Aztec mansion, another with the façade in the style of the North American deep South; a small mansion with a fortified tower and many, many oddities that it's better to see than to describe.

Patricio Bayardo Gómez, Tijuana hoy, Ediciones del XIII Ayuntamiento, Tijuana, 1991, p. 9.

"TIJUANA HAS MORE TO DO WITH SCIENCE FICTION NOVELS THAN WITH BOOKS OF MEXICAN HISTORY."

Raúl Cárdenas (Torolab), interview, 2004.

- In 2002 the city of San Diego had a population of 1,255,742, and the County had 2,918,254, while Tijuana in this period had 1,292,993 inhabitants, according to official figures.

- The index of population growth in San Diego was 2.8%; in Tijuana, 4.9%.

- The average age in 2000 was 33 years in San Diego; 24.8 years in Tijuana.

- The per capita income in the Californian city during 2001 went up to $33,883; in Tijuana, $9,812.

- In 1999, the poverty index in San Diego was 12% (23.2% in Rainbow and 1.5% in Hidden Meadows). In 2000 in Tijuana, this same index was 18.4%.

www.icfdn.org/aboutus/publications/blurrborders

Fast-growing Tijuana suffers from an exaggerated, largely outdated reputation as a tawdry booze-and-sex border town, a gaudy place whose curio stores overflow with kitschy souvenirs like wrought iron birdcages and ceramic burros. That Tijuana still exists, but the developing cityscape of modernistic office buildings, housing developments and maquiladoras marks Baja California's largest border city as a place of increasing sophistication. Certain areas, such as the Zona Río southeast of downtown, may sink under the weight of shopping centers that make them seem like extensions of mainland Southern California's mall culture.

Baja California, Hawthorn: Lonely Planet, 1998, p. 102.

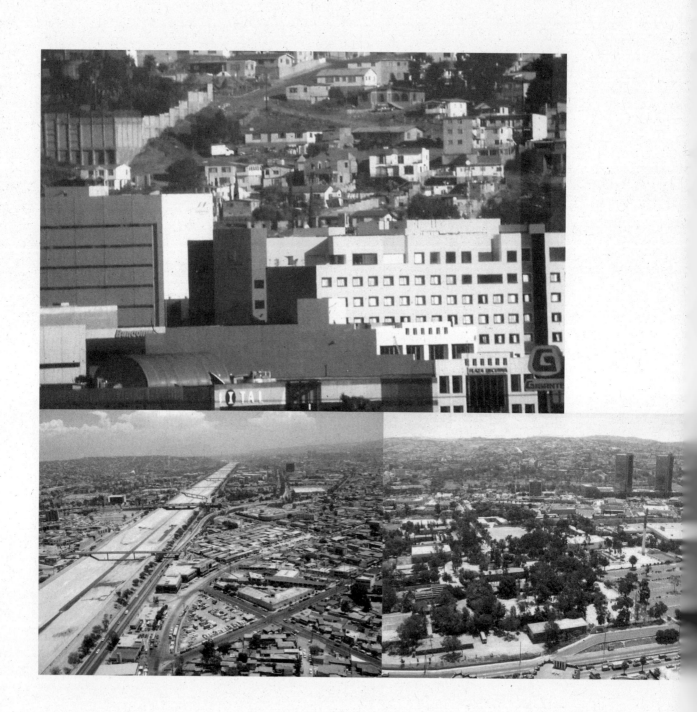

Different from the monocentric city model of the industrial revolution, where employment activities were grouped at a center ringed by residential developments of decreasing density; or from the dispersed American model where several centers are surrounded by a quilt of suburban development; a distinctive characteristic of Tijuana's peripheral development is that large and dense urban concentrations are linked by transportation networks across a field that is relatively vacant. The condition in Tijuana reflects an urbanism born from an under–regulated approach to development; a density that happened as a result of economic Darwinism within a limited envelope; where sprawl takes on an unapologetic urban form. There, urban mass exist as figures without any textual middle ground, spawning conglomerations which form new monuments in the periphery.

Mark Lee, email conversation, Los Angeles/Tijuana, 2004.

Tijuana escapes the monotony of the rest of the border owing to its topography. While the rest of the important cities are found on flat desert lands, Tijuana is a latticework of mountains interrupted to the west by the ocean.

But this is because of an optical illusion. The form in which the inhabitants have constructed their homes retains the same criteria of functionality and aesthetics that can be seen in the rest of the Mexican borderlands.

In the Playas area, within Tijuana itself, houses in the Californian style predominate, in which half the residents are North Americans.... The rest of the urban area loses uniformity and allows neighborhoods to coexist with government-financed housing, areas in which the families decided to modestly expand their homes, and large extensions of neighborhoods with no basic services.

Ignacio Alvarado Alvarez, "The Thousand Faces of the Border," www.almargen.com.mx

Since the actual checkpoint is a few hundred meters into the US territory, the real borderline – barely inscribed on the pavement by a series of dots – disappears temporarily, allowing vendors to roam back and forth over the political division.... This adventure of the imagination ends when we encounter the U.S. immigration officer whose vigilant mask mirrors the reality we have created, one of isolation, separation and displacement.

Teddy Cruz, "The Tijuana Workshop," *Architecture of the Borderlands*, Architectural Design, vol. 69 7/8, 1999, p. 43.

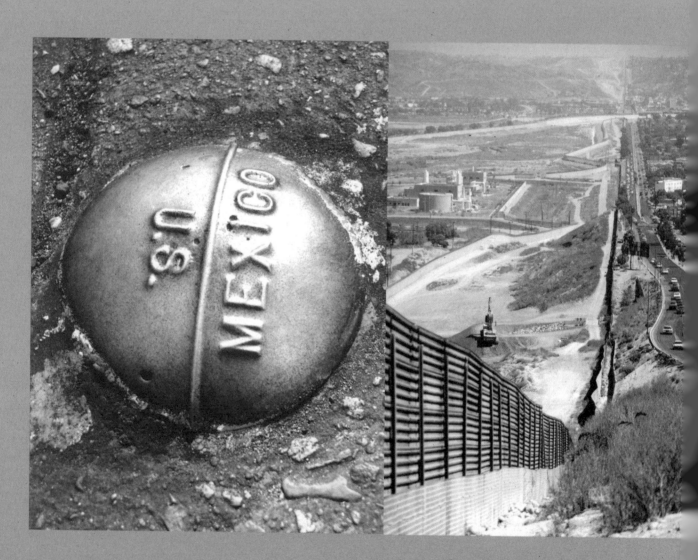

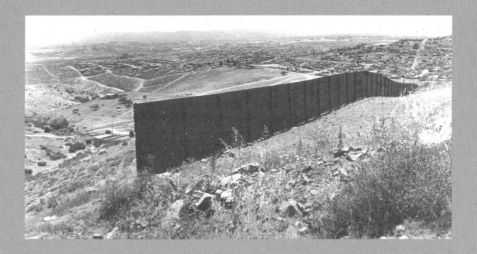

■ Deaths along the Mexico-United States border since the
implementation of Operation Gatekeeper (October 1, 1994):

1995 – 61
1996 – 59
1997 – 89
1998 – 261
1999 – 213
2000 – 370
2001 – 322
2002 – 320
2003 – 339
2004 – 373

The strategy consists in reinforcing the traditional routes of
migration, leading them towards the mountains and desert. In the
Tijuana–San Diego zone this occurs by causing the migration to
move towards the mountains and deserts east of San Diego, where
temperatures surpass 122 degrees Fahrenheit.

The crossing lasts two or more days.

From the beginning of Gatekeeper migrant deaths have gone up 500%.

From www.stopgatekeeper.org, Coalición Pro Defensa del Migrante, and Reforma.

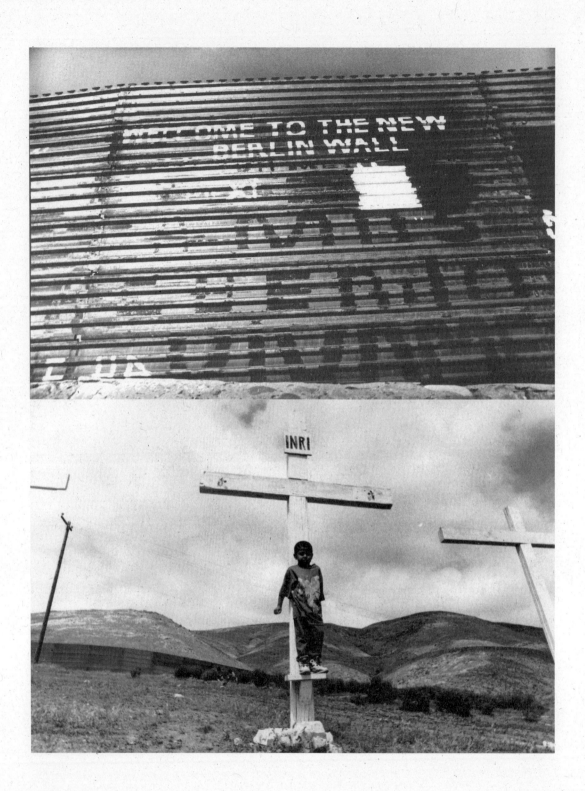

"THE CONCEPT THAT THE UNDOCUMENTED PERSON IS A CRIMINAL AND SHOULD BE TREATED AS SUCH IS REFLECTED IN THE ARCHITECTURE OF THE NEW MIGRANTS' AGENCY BUILDING OF TIJUANA: HIGH BARS, MADE OF THICK TUBING, THAT REPEAT THE DESIGN OF THE SECOND FENCE THAT THE UNITED STATES CITIZENS INSTALLED PARALLELING THE FIRST METALLIC, RUSTED FENCE CONSTRUCTED ORIGINALLY TO TRY TO SLOW DOWN THE UNDOCUMENTED. THERE IS NO FREE EXIT TO THE LITTLE BACK PATIO. THERE ARE NO BEDS, ONLY A SLAB OF CEMENT ATTACHED TO THE WALLS SO THAT THERE THOSE WHO WILL BE EXPELLED CAN SIT OR LIE."

ciss.insp.mx/migracion/noticias/not_main.php?id_not=571&accion=mostrar

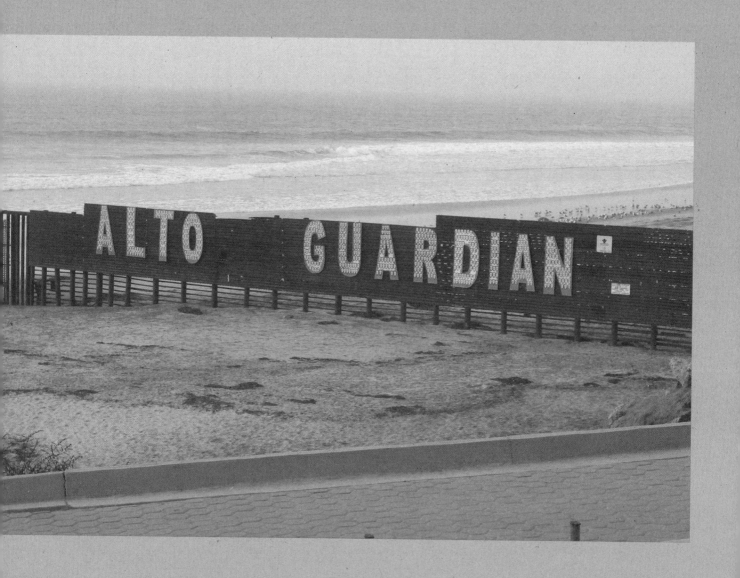

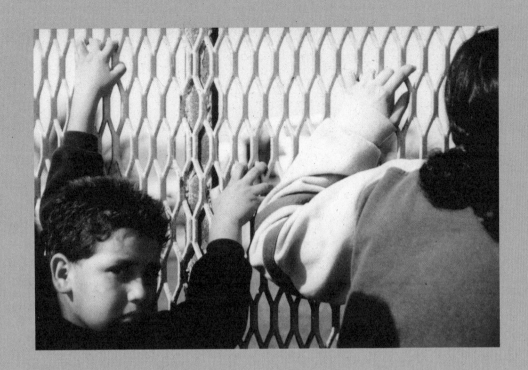

IN ITS OCTOBER **30, 2004,** EDITION, THE POLICE BEAT COLUMN OF THE DAILY *EL MEXICANO* HELD THAT **"**IF A CROSS WERE SET IN EACH PLACE WHERE A PERSON WAS FOUND WHO HAD BEEN ASSASSINATED, TIJUANA WOULD BE THE BIGGEST CEMETERY IN THE COUNTRY.**"**

El Mexicano, October 30, 2004.

Finally, it is important to know the time that it takes to do a book like this one. While researching, writing, editing, and distributing, the state continues its development. We readers should salvage, through research, the information in order increasingly to know better the place where we live.

Baja California. Tierra extremosa y riqueza de los mares, México: Secretaría de Educación Pública, 1992, p. 200.

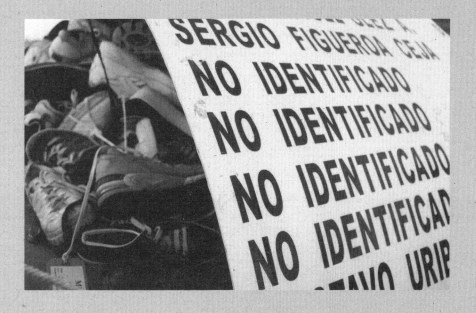

" MY BELOVED TIJUANA: ARE YOU BAPTIZED? "

Julio Armando Ramírez, "Buenas noches Tijuana," recited by a student from
Preparatoria Federal Lázaro Cárdenas.

" TIJUANA'S DEVELOPMENT IS A CONSEQUENCE OF ILLICIT ACTS OF URBANISM. "

René Peralta, www.generica.blogspot.com

Now, finally, Carlos Salinas's gang... he made it so that all of Mexico would
become Tijuana, which already for some years had been held up as a
prototype of the Mexican city at the close of the century.... There are
usually three views of Tijuana: that of the foreigners, that of Mexicans, and
the internal one, that of Tijuanans. All of them, as is natural and human,
abound in stereotypes.... All Mexico is Tijuana.

Federico Campbell, "La tijuanización de México," *Revista de diálogo cultural entre las Fronteras de
México,* no. 1, 1996, p. 16.

Of course on arriving in Tijuana I saw your mother up in the back
of a truck surrounded by Mexican braceros, all drunk, all
singing, all happy. If she saw me she acted like she didn't.
Seems that the good woman goes on winning. Tijuana
goes out into the desert like an oil stain on an ice rink.

Ray Loriga, *Tokio ya no nos quiere,* Barcelona: Plaza & Janés, 1999, p. 24.

" TIJUANA IS NOT TIJUANA. "

Fiamma Montezemolo, www.worldviewcities.org

" WE DON'T HAVE AN OLD LEGEND OF SONGS AND MYSTERIES; WE ARE FORGING OUR LEGEND NOW. "

María de la Luz Pulido Vera, designer of the regional dress of Baja California.

And in his sick mind he affirmed the fiction, looked at a gravestone:
'Here lies Gloria de Zaragoza.'
'Stop looking for her. Only Tijuana In remains.'
'Really? Well, I love Tijuana In. I love you for yourself! The past doesn't matter to me.
Vicious, criminal, whatever; I love you; but you also love me, a little...'
'Tijuana In loves no one. And don't be offended. Let's go get a drink.'

Hernán de la Roca, *Tijuana In 1931,* Tijuana: Ediciones del XIII Ayuntamiento, 1990, p. 98.

From: Scott Corrales <lornis1@juno.com>
To: UFO UpDates-Toronto <ufoupdates@virtuallystrange.net>
Date: Sun, 8 Sep 2002 09:33:28 -0400
Subject: UFO Seen In Tijuana
SOURCE: Terra.Cl and Gran Diario Regional El Mexicano
DATE: September 7, 2002
UFO SEEN OVER TIJUANA, MEXICO
** Strange craft's maneuvers were seen by a large number of people**
September 7 – Dozens of residents of Avenida Porticos in San Antonio de Los Buenos
(Tijuana, Mexico) claim having seen a UFO in the early morning hours of September
1st. It had a diameter of approximately 50 meters and it remained suspended over
this area at low altitude, even while covered by a cloud.

No matter how much border patriotism is trumpeted, what's
significant is the process where the economic connection
with the United States becomes a life style, or even a
musical atmosphere.

Carlos Monsiváis, conference, Tijuana, 2001.

$$\text{TIJUANA} = \frac{\text{MÉXICO} + \text{USA}}{\text{MEX \& CO.} - \text{ESTADOS UNIDOS}} \neq \text{TIJUANA}$$

Heriberto Yépez, www.hyepez.blogspot.com

Tijuana and its border with the United States determine a
paradigmatic profile adjusted to a reality completely
connected to the chief contradiction between a techno-
globalized and economically strong world, 'the north,'
and a world that fights for its own cultural and globalized
identities in economic poverty, 'the south.' A space where
the south is found along with the north, where the center
is found along with the periphery, but a meeting that
happens through walls and a world of disconnections and
disqualifications of the human condition.

Pablo Bransburg, Interview 2004. San Diego, California.

¿SALDOS DE TI, CIUDAD?

Francisco Morales, "La ciudad que recorro," en *Baja California
Piedra Serpiente. Prosa y poesía (siglos XVII–XX)*, México:
Consejo Nacional para la Cultura y las Artes, 1993, p. 35.

" **FRIVOLOUS BORDER PROGRESSIVENESS
(...) THIS IS MY TRUE IMPOVERISHED HOUSE.** "

Rubén Vizcaíno, "Perdón por tener todavía mis ojos," in *Across the Line / Al otro lado. The Poetry
of Baja California*, eds. Harry Polkinhorn and Mark Weiss, San Diego: Junction Press, 2002, p. 42.

PHOTO CREDITS

FIAMMA MONTEZEMOLO PhD in Cultural Anthropology, Istituto Orientale di Napoli. Professor at Colegio de la Frontera Norte, Cultural Studies Department in Tijuana and teaches urban anthropology at Woodbury University in San Diego. Latest books and publications: *Senza Volto: identitá e genere nel movimento zapatista*, Napoli: Liguori, 1999; *La Mia Storia Non La Tua: la costruzione dell'identitá chicana tra etero e autorappresentazioni*, Milano: Guerini, 2004.

RENÉ PERALTA Educated at the New School of Architecture in San Diego California and at the Architectural Association in London. A native of Tijuana, he has taught at Universidad Iberoamericana in Tijuana, New School of Architecture and Woodbury University in San Diego and was visiting faculty at UCLA in 2005. René has published texts and lectured in the US, México, Cuba and Italy. His latest work includes "Worldview: Tijuana," a web based report on architecture and urbanism, for The Architectural League of New York. Principal and founder of Generica Arquitectura in Tijuana.

HERIBERTO YEPEZ Teaches critical theory in the Arts and Humanities Schools, at Universidad Autonoma de Baja California, in Tijuana, Mexico. He has published seven books of fiction, poetry and essays, including two novels *El matasellos* and *A.B.U.R.T.O*, New York: Random House, 2003 and 2005. He writes both in English and Spanish and is a practicing psychotherapist.

ACKNOWLEDGMENTS Photography and Image Funding Support:
Insite05

Graphic Coordinator:
Sirak Peralta

Institutional and Academic Support:
El Colegio de la Frontera Norte
Generica
Instituto Municipal de Planeación
Universidad Autónoma de Baja California

We also want to thank:
Francisco Cabanillas, Miguel Franco, Librería El Día, Antoni Muntadas, Rogelio Núñez, Mónica Peralta, Renée Michelle Peralta, Sergio Rommel, Osvaldo Sánchez, Luís Elías Sanz, Gabriela Soriano, Oscar Sosa, Karlo de Soto, Laura Velasco, Héctor Villanueva and the artists, photographers, writers, journalists, researchers, architects and the Tijuana community in general

English translation:
Harry Polkinhorn